Angela-J. Pye

THE GRAPHIC WORK OF M. C. ESCHER

D0246154

THE GRAPHIC WORK OF M.C.ESCHER

Introduced and explained by the artist

PAN/BALLANTINE 33 TOTHILL STREET LONDON S.W. 1

All rights reserved. No part of this book in excess of 500 words, and no illustration, may be reproduced in any form without permission in writing from the publishers.

S.B.N. 0345 - 09774 - 2

TRANSLATED FROM THE DUTCH BY JOHN E. BRIGHAM

O Koninklijke uitgeverij Erven J. J. Tijl N.V., Zwolle, Holland, 1960

O English translation copyright Oldbourne Book Co. Ltd. 1961

First printing, December 1972 Second printing, December 1972 Third printing, February 1973 Fourth printing, September 1973 Fifth printing, April 1974

Pan/Ballentine, 33 Tothill Street, London S.W. 1

CONTENTS

Introduction	page	7		
Classification and Description		11		
I. EARLY PRINTS				
Tower of Babel	nr.	1		
Castrovalva		2		
Palm		3		
Portrait G. A. Escher		4		
Fluorescent sea		5		
St. Peter's, Rome		6		
Dream		7		
II. REGULAR DIVISION OF A PLANE				
Horseman		8		
Swans		9		
Two intersecting planes		10		
Day and night		11		
Sun and moon		12		
Sky and water I		13		
Sky and water II		14		
Liberation		15		
Development I		16		
Verbum		17		
Smaller and smaller		18		
Path of life II		19		
Sphere surface with fishes		20		
Whirlpools		21		
Circle limit I		22		
Circle limit IV		23		
Circle limit III		24		
Square limit		25		
Fishes and scales		26		
Butterflies		27		

Reptiles	28
Cycle	29
Encounter	30
Magic mirror	31
Metamorphosis	32
Predestination	33
Mosaic I	34
Mosaic II	35
III. UNLIMITED SPACES	
Three intersecting planes	36
Cubic space-division	37
Depth	38
IV. SPATIAL RINGS AND SPIRALS	
Knots	39
Moebius strip II	40
Moebius strip I	41
Spirals	42
Sphere spirals	43
Concentric rinds	44
Rind	45
Bond of union	46
V. MIRROR IMAGES	
Rippled surface	47
Three worlds	48
Puddle	49
Still life with reflecting globe	50
Hand with reflecting globe	51
Three spheres II	52
Dewdrop	53
Eye	54

VI. INVERSION	
Cube with magic ribbons	55
Convex and concave	56
VII. POLYHEDRONS	
Double planetoid	57
Tetrahedral planetoid	58
Order and chaos	59
Gravity	60
Stars	61
Flat worms	62
VIII. RELATIVITIES	
Another world	63
High and low	64
Curl-up	65
House of stairs	66
Relativity	67
IX. CONFLICT FLAT-SPATIAL	
Three spheres I	68
Drawing hands	69
Balcony	70
Doric columns	71
Print gallery	72
Dragon	73
X. IMPOSSIBLE BUILDINGS	
Belvedere	74
Ascending and descending	75
Waterfall	76
Biographical notes	

EIGHT HEADS, woodcut stamped-print, 1922.

This is the first regular division of a plane surface carried out by the artist, when he was a pupil of the School of Architecture and Decorative Arts in Haarlem. It indicates at what an early stage he felt drawn to rhythmic repetition. In the original wood-block eight heads were cut, four female and four male. Space can be filled to infinity with contiguous prints.

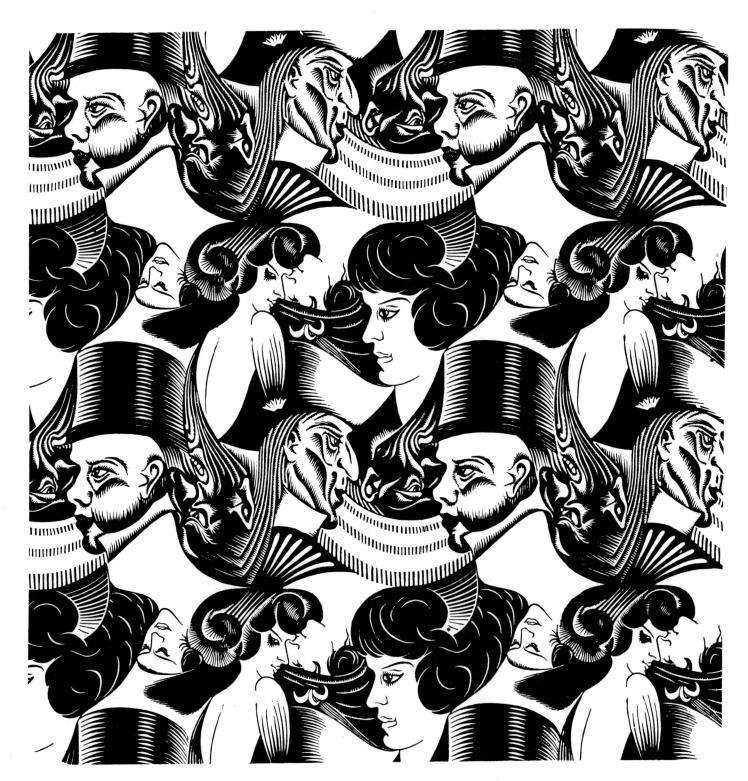

INTRODUCTION

Anyone who applies himself, from his early youth, to the practice of graphic techniques may well reach a stage at which he begins to hold as his highest ideal the complete mastery of his craft. Excellence of craftsmanship takes up all his time and so completely absorbs his thoughts, that he will even make his choice of subject subordinate to his desire to explore some particular facet of technique. True enough, there is tremendous satisfaction to be derived from the acquisition of artistic skill and the achievement of a thorough understanding of the properties of the material to hand, and in learning with true purposefulness and control to use the tools which one has available — above all, one's own two hands!

I myself passed many years in this state of self-delusion. But then there came a moment when it seemed as though scales fell from my eyes. I discovered that technical mastery was no longer my sole aim, for I became gripped by another desire, the existence of which I had never suspected. Ideas came into my mind quite unrelated to graphic art, notions which so fascinated me that I longed to communicate them to other people. This could not be achieved through words, for these thoughts were not literary ones, but mental images of a kind that can only be made comprehensible to others by presenting them as visual images. Suddenly the method by which the image was to be presented became less important than it used to be. However, one does not of course study graphic art for so many years to no avail; not only had the craft become second nature to me, it had also become essential to continue using some technique of reproduction that would enable me to communicate simultaneously to a large number of my fellow men that which I was aiming at.

If I compare the way in which a graphic sheet from my technique period came into being with that of a print expressing a particular train of thought, then I realize that they are almost poles apart. What often happened in the past was that I would pick out from a pile of sketches one which seemed to me suitable for reproduction by means of the same technique that was interesting me at that moment. But now it is from amongst those techniques which I have to some degree mastered, that I choose out the one which lends itself more than any other, to the expression of the particular idea that has taken hold of my mind.

Nowadays the growth of a graphic image can be divided into two sharply defined phases. The process begins with the search for a visual form that will interpret as clearly as possible one's train of thought. Usually a long time elapses before I decide that I have got it clear in my mind. Yet a mental image is something completely different from a visual image, and however much one exerts oneself, one can never manage to capture the fullness of that perfection which hovers in the mind and which one thinks of, quite falsely, as something that is "seen". After a long series of attempts, at last — when I am just about at the end of my resources — I manage to cast my lovely dream in the defective visual mould of a detailled conceptual sketch. After this, to my great relief, there dawns the second phase, that is the making of the graphic print; for now the spirit can take its rest while the work is taken over by the hands.

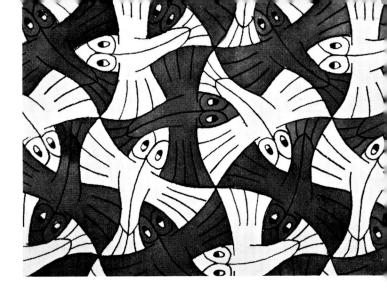

In 1922, when I left the School of Architecture and Ornamental Design in Haarlem, having learnt graphic techniques from S. Jessurun de Mesquita; I was very much under the influence of this teacher, whose strong personality certainly left its mark on the majority of his pupils. At that period the woodcut (that is to say the cutting with gouges in a side-grained block of wood, usually pear) was more in vogue with graphic artists than is the case today. I inherited from my teacher his predilection for sidegrained wood, and one of the reasons for my everlasting gratitude to him stems from the fact that he taught me how to handle this material. During the first seven years of my time in Italy I used nothing else. It lends itself, better than the costly end-grained wood, to large-side figures. In my youthful recklessness I have gouged away at enormous pieces of pearwood, not far short of three feet in length and perhaps two feet wide. It was not until 1929 that I made my first lithograph, and then in 1931 I tried my hand for the first time at wood-engraving, that is to say engraving with burins on an end-grain block. Yet even today the woodcut remains for me an essential medium. Whenever one needs a greater degree of tinting or colouring in order to communicate one's ideas, and for this reason has to produce more than one block, the woodcut offers many advantages over wood-engraving, and there have been many prints in recent years that I could not have produced had I not gained a thorough knowledge of the advantages of sidegrained wood. In making a colour-print I have often combined both of these raised relief techniques, using end-grain for details in black, and side-grain for the colours.

The period during which I devoted such enthusiasm to my research into the characteristics of graphic materials and during which I came to realise the limitations that one must impose on oneself when dealing with them, lasted from 1922 until about 1935. During that time a large number of prints came into being (about 70 woodcuts and engravings and some 40 lithographs). The greater number of these have little or no value now, because they were for the most part merely practice exercises: at least that is how they appear to me now.

The fact that, from 1938 onwards, I concentrated more on the interpretation of personal ideas was primarily the result of my departure from Italy. In Switzerland, Belgium and Holland where I successively established myself, I found the outward appearance of landscape and architecture less striking than those which are particularly to be seen in the southern part of Italy. Thus I felt compelled to withdraw from the more or less direct and true to life illustrating of my surroundings. No doubt this circumstance was in a high degree responsible for bringing my inner visions into being.

On one further occasion did my interest in the craft take the upper hand again. This was in 1946 when I first made the acquaintance of the old and highly respectable black art technique of the mezzotint, whose velvety dark grey and black shades so attracted me that I devoted a great deal of time to the mastery of this copperplate intaglio, a process that has today fallen almost entirely into disuse. But before long it became clear that this was going to be too great a test of my patience. It claims far too much time and effort from anyone who, rightly or wrongly, feels he has no time

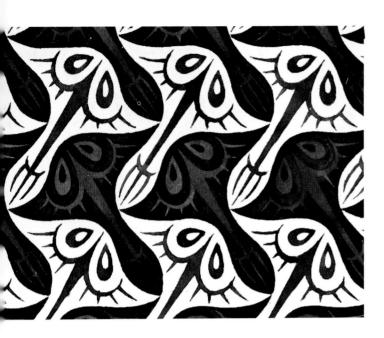

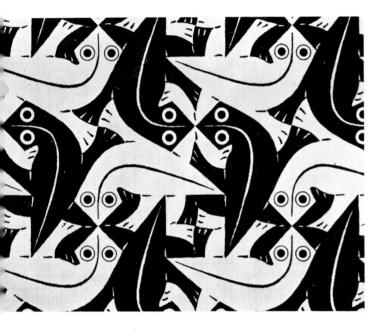

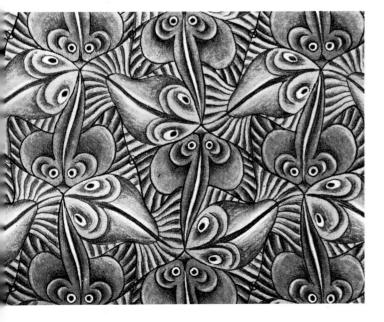

to lose. Up to the present I have, in all, produced no more than seven mezzotints, the last one being in 1951.

I have never practised any other type of intaglio. From the moment of my discovery, I have deliberately left etching and copper-plate engraving to one side. The reason for this can probably be traced to the fact that I find it preferable to delineate my figures by means of tone-contrast, rather than by linear contour. The thin black line on a white background, which is characteristic of etching and copper-engraving, would only be of use as a component part of a shaded area, but it is not adequate for this purpose. Morever, with intaglio, one is much more tied to white as a starting point than is the case with raised relief and planography. The drawing of a narrow white line on a dark surface, for which raised relief methods are eminently suitable, is practically impossible with intaglio, while on the other hand, a thin black line on a white background can be satisfactorily achieved, albeit as a rather painstaking operation, in woodcuts and woodengravings.

Apart from prints 1 to 7 inclusive, all the numbered reproductions in this book were made with a view to communicating a specific line of thought. The ideas that are basic to them often bear witness to my amazement and wonder at the laws of nature which operate in the world around us. He who wonders discovers that this is in itself a wonder. By keenly confronting the enigmas that surround us, and by considering and analyzing the observations that I had made, I ended up in the domain of mathematics. Although I am absolutely without training or knowledge in the exact sciences, I often seem to have more in common with mathematicians than with my fellow artists.

On reading over what I wrote at the beginning of this introduction, about the particular representational character of my prints, I feel it may be rather illogical to devote so many words to it, not only here but also beside each separate reproduction as well. It is a fact, however, that most people find it easier to arrive at an understanding of an image by the round-about method of letter symbols than by the direct route. So it is with a view to meeting this need that I myself have written the text. I am well aware that I have done this very inadequately, but I could not leave it to anyone else, for — and here is yet another reason for my astonishment no matter how objective or how impersonal the majority of my subjects appear to me, so far as I have been able to discover, few if any of my fellow-men seem to react in the same way to all that they see around them.

M. C. Escher

CLASSIFICATION AND DESCRIPTION OF THE NUMBERED REPRODUCTIONS

I. EARLY PRINTS. 1-7

The five prints in this group, selected from a large number which were made before 1937, display no unity as far as their subject matter is concerned. They are all representations of observed reality. Even No. 7, "Dream", although pure fantasy, consists of elements which, taken separately, are realistically conceived.

1. TOWER OF BABEL, woodcut, 1928, 62 x 38.5 cm

On the assumption that the period of language confusion coincided with the emergence of different races, some of the building workers are white and others black. The work is at a standstill because they are no longer able to understand each other. Seeing that the climax of the drama takes place at the summit of the tower which is under construction, the building has been shown from above, as though from a bird's eye view. This called for a very sharply receding perspective. It was not until twenty years later that this problem was thoroughly thought out. (see 63, Another World et seq).

2. CASTROVALVA, lithograph, 1930, 53 x 42 cm A mountainous landscape in the Abruzzi.

3. PALM, wood-engraving printed from 2 blocks, 1933, 39.5 x 29.5 cm

4. PORTRAIT OF IR. G. A. ESCHER, father of the artist, in his 92nd year, lithograph, 1935, 26.5 x 21 cm

In the case of the portraiture of someone with strongly assymetrical features, a great deal of the likeness is lost in the print, for this is the mirror image of the original work. In this instance a contraprint was made; that is to say, while the ink of the first print was still wet on the paper, this was printed on to a second sheet, thereby annulling the mirror image. The "proof" brings out the signature that he himself wrote on the stone with lithographic chalk and which is now to be seen, doubly mirrored, back in its original form.

5. FLUORESCENT SEA, lithograph, 1933, 33 x 24.5 cm

6. ST. PETER'S, ROME, wood-engraving, 1935, $24 \times 32 \text{ cm}$ The convergence of the vertical lines towards the nadir suggests the height of the building in which the viewer finds himself, together with the feeling of vertigo that takes hold of him when he looks down.

7. DREAM, woodcut, 1935, 32 x 24 cm

Is the bishop dreaming about a praying locust, or is the whole conception a dream of the artist?

II. THE REGULAR DIVISION OF A PLANE. 8-35

This is the richest source of inspiration that I have ever struck: nor has it yet dried up. The symmetry-drawings on the foregoing and following page show how a surface can be regularly divided into, or filled up with, similar-shaped figures which are contiguous to one another, without leaving any open spaces. The Moors were past masters of this. They decorated walls and floors, particularly in the Alhambra in Spain, by placing congruent, multi-coloured pieces of majolica together without leaving any spaces between. What a pity it is that Islam did not permit them to make "graven images". They always restricted themselves, in their massed tiles, to designs of an abstract geometrical type. Not one single Moorish artist, to the best of my knowledge, ever made so bold (or maybe the idea never occurred to him) as to use concrete, recognisable, naturistically conceived figures of fish, birds, reptiles or human beings as elements in their surface coverage. This restriction is all the more unacceptable to me in that the recognizability of the components of my own designs is the reason for my unfailling interest in this sphere.

a. Glide Reflexion. 8-9-10

Anyone who wishes to achieve symmetry on a flat surface must take account of three fundamental principles of crystallography: repeated shifting (translation); turning about axes (rotation) and gliding mirror image (reflexion). It would be an exaggeration to attempt to discuss all three of them in this short treatise, but seeing that glide reflexion is definitely displayed in three of my prints, I must pay special attention to it.

8. SWANS, wood-engraving, 1956, 20 x 32 cm

The swans in this example of glide reflexion are flying round in a closed circuit formed like a recumbent figure eight. In order to pass over to its mirror image, each bird has got to raise itself up like a flat biscuit sprinkled with sugar on one side and spread with chocolate on the other. In the middle, where the white and black streams cross, they fill up each other's open spaces. So a completely square surface pattern is created. (See also symmetry drawing B.)

9. HORSEMAN, woodcut printed from three blocks, 1946, 24 x 45 cm

In order to indicate that the light-shaded horsemen are the mirror images of the dark-shaded ones, a circular band is portrayed on which a procession of horsemen moves forward. One can imagine it to be a length of material, with a pattern woven into it, the warp and woof being of different colours. The dark knights on the light background thereby change colour on the reverse side of the band. In the middle both front and back have become enmeshed and now it appears that light and dark horsemen together fill up the space completely. (See also drawing A.)

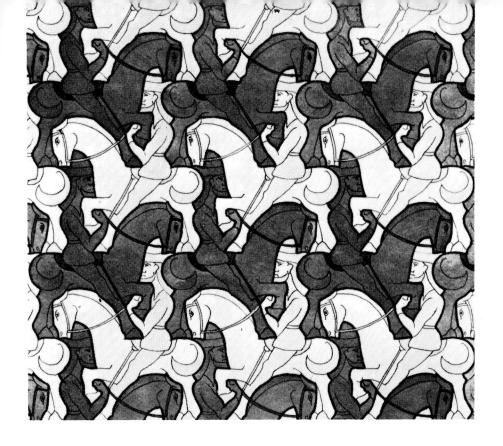

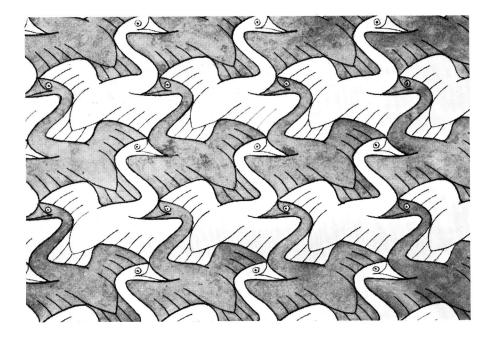

Symmetry drawing B

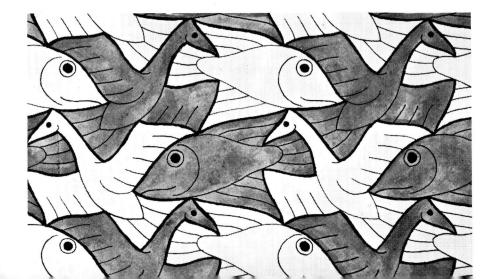

Symmetry drawing C

Symmetry drawing A

10. TWO INTERSECTING PLANES, woodcut printed from 3 blocks, 1952, 22 x 32 cm

Two thin, flat rectangular boards intersect each other at a slight angle. Holes have been sawn in each board leaving openings shaped like fishes and birds. The holes in one board can be filled up by the remaining parts of the other board. The jigsaw pieces of the one are mirror images of those in the other (see also symmetry drawing C).

b. The function of figures as a back-ground. 11-14

Our eyes are accustomed to fixing upon a specific object. The moment this happens everything round about becomes reduced to background.

11. DAY AND NIGHT, woodcut printed from two blocks, 1938, 39 x 68 cm

Grey rectangular fields develop upwards into silhouettes of white and black birds; the black ones are flying towards the left and the white ones towards the right, in two opposing formations. To the left of the picture the white birds flow together and merge to form a daylight sky and landscape. To the right the black birds melt together into night. The day and night landscapes are mirror images of each other, united by means of the grey fields out of which once again the birds emerge.

12. SUN AND MOON, woodcut printed from four blocks, 1948, 25 x 27.5 cm

The subject of this coloured woodcut is once again the contrast between day and night. But in this instance the two notions are not, as in plate 11, pictured as next to each other but in the same place — though not simultaneous, being separated by a leap of the mind. It is day-time when there is a sun shining in the centre, where the sun is shooting out yellow and red rays. Against this background stand out fourteen dark blue birds. As soon as one divests them of their function as objects and regards them as background, then there appear fourteen light coloured birds against a night sky, with a crescent moon in the centre and with stars, planets and a comet.

13. SKY AND WATER I, woodcut, 1938, 44 x 44 cm

In the horizontal central strip there are birds and fish equivalent to each other. We associate flying with sky, and so for each of the black birds the sky in which it is flying is formed by the four white fish which encircle it. Similarly swimming makes us think of water, and therefore the four black birds that surround a fish become the water in which it swims.

14. SKY AND WATER II, woodcut, 1938, 28 x 26 cm

Similar in subject to that in no. 13 Sky and Water I, except that the birds and fishes are to be seen here in direct as well as in mirror image.

c. Development of form and contrast. 15-16-17

15. LIBERATION, lithograph, 1955, 43.5 x 20 cm

On the uniformly grey surface of a strip of paper that is being unrolled, a simultaneous development in form and contrast is taking place. Triangles, at first scarcely visible, change into more complicated figures, whilst the colour contrast between them increases. In the middle they are transformed into white and black birds, and from there fly off into the world as independent creatures. And so the strip of paper on which they were drawn disappears.

16. DEVELOPMENT I, woodcut, 1937, 44 x 44 cm

Scarcely visible grey squares at the edges evolve in form and contrast towards the centre. Their growth is completed in the middle. An unsatisfactory feature of this kind of inward-directed unfolding is that there is so little space left for the freedom of movement of the most greatly developed figures: two white and two black reptiles.

17. VERBUM, lithograph, 1942, 33 x 38.5 cm

An evolution working from the centre outwards, thus the opposite way round to the previous print, offers more space at the edges for the fully grown figures. The central word "Verbum" recalls the biblical story of creation. Out of a misty grey there loom triangular primeval figures which, by the time they reach the edges of the hexagon, have developed into birds, fishes and frogs, each in its own element: air, water and earth. Each kind is pictured by day and by night, and the creatures merge into each other as they move forward along the outline of the hexagon, in a clockwise direction.

d. Infinity of number. 18-27

If all component parts are equal in size, it is impossible to represent more than a fragment of a regular plane-filling. If one wishes to illustrate an infinite number then one must have recourse to a gradual reduction in the size of the figures, until one reaches — at any rate theoretically — the limit of infinite smallness.

18. SMALLER AND SMALLER, wood-engraving printed from four blocks, 1956, 38 x 38 cm

The area of each of the reptile-shaped elements of this pattern is regularly and continuously halved in the direction of the centre, where theoretically both infinite smallness of size and infinite greatness of number are reached. However, in practice, the wood-engraver soon comes to the end of his ability to carry on. He is dependent on four factors: 1. the quality of his wood-block, 2. the sharpness of the instrument that he is using, 3. the steadiness of his hand and, 4. his optical ability (good eyesight, plenty of light and a powerful magnifying lens). In this particular case, the halving of the figures is carried through ad absurdum. The smallest animal still possessing a head, a tail and four legs is about 2 millimetres in length. From the point of view of composition, this work is only partially satisfactory. In spite of the central limit, it remains only a fragment, because the outer edge of the pattern has been arbitrarily fixed. So a complete composition has not been achieved.

19. PATH OF LIFE II, woodcut printed from two blocks, 1958, 37 x 37 cm

Here too the point of infinite smallness is in the centre. This time an attempt has been made to eliminate the unsatisfactory reature of an illogical limit. The area is filled with white and grey fishshaped figures whose longitudinal axes are accentuated by black lines. Out from the central point come four series of white fishes (rays) swimming head to tail in a spiral motion. The four largest specimens, which close off the square surface, change direction and colour; their white tails still belong to the centrifugal movement, but their grey heads are already turning inwards and so form part of the grey series which are moving back towards the centre.

20. SPHERE SURFACE WITH FISHES, woodcut printed from two blocks, 1958, diameter 32 cm

The previous print demonstrated a return motion towards the starting point. There now follow variations on that theme, with two cores, a starting point and an end point between which the chains of figures move. Here, as a first example, is a sphere with two poles and a network of longitudinal and latitudinal circles. Swimming spirally outwards from the one visible pole, there come alternate rows of white and black fishes. They attain their greatest size on reaching the equator and thereafter they become smaller and disappear into the other, invisible, pole on the far side of the sphere.

21. WHIRLPOOLS, woodcut printed from 2 blocks , 1957, 45 x 23.5 cm

45 x 23.5 cm

Closely related to the foregoing picture, there is here displayed a flat surface with two visible cores. These are bound together by two white S-shaped spirals, drawn through the bodily axes of, once again, fishes swimming head to tail. But in this case they move forward in opposite directions. The upper core is the starting point for the dark-coloured series, the component members of which attain their greatest size in the middle of the picture. From then on, they come within the sphere of influence of the lower core, towards which they keep on swirling until they disappear within it. The other, light-coloured, line makes the same sort of journey but in the opposite direction. As a matter of special printing technique, I would point out that only one wood-block is used for both colours, these having been printed one after the other on the same sheet of paper, and turned 180 degrees in relation to each other. The two prints fill up each other's open spaces.

22. CIRCLE LIMIT I, woodcut, 1958, diameter 42 cm

So far four examples have been shown with **points** as limits of infinite smallness. A diminution in the size of the figures progressing in the opposite direction, i.e. from within outwards, leads to more satisfying results. The limit is no longer a point, but **a line** which borders the whole complex and gives it a logical boundary. In this way one creates, as it were, a universe, a geometrical enclosure. If the progressive reduction in size radiates in all directions at an equal rate, then the limit becomes a circle. In the example in question (chronologically the first of the three which have been included in this book), the arrangement of the component parts still leaves much to be desired. All the lines, once again accentuated by the bodily axes, consist of alternating pairs of fish, two white ones head to head and two black ones whose tails touch. So there is no continuity here, no direction of forward movement, nor is there any unity of colour in each line.

23. CIRCLE LIMIT IV, (Heaven and Hell), woodcut printed from 2 blocks, 1960, diameter 42 cm

Here also we have the components diminishing in size as they move outwards. The six largest (three white angels and three black devils) are arranged about the centre and radiate from it. The disc is divided into six sections in which, turn and turn about, the angels on a black background and then the devils on a white one, gain the upper hand. In this way, heaven and hell change place six times. In the intermediate, "earthly" stages, they are equivalent.

24. CIRCLE LIMIT III, woodcut printed from 5 blocks, 1959, diameter 41.5 cm

Here, the failings of the previous work are as far as possible remedied. White curved lines cut across each other and divide one another into sections, each of which equals the length of a fish. They mark the routes along which series of fish move forward, from the infinitely small, through the greatest size, to infinitely small. Each series comprises fish of only one colour. It is necessary to have at least four colours so as to get the lines of fish to contrast with each other. It is worthy to mention, from the point of view of printing technique, that five wood-blocks were made, one for the black lines and four for the colours. Each block has the shape of a right-angled segment and so has to be printed four times over in order to fill the circle. Therefore a complete copy of this print requires $4 \times 5 = 20$ impressions.

25. SQUARE LIMIT, woodcut printed from 2 blocks, 1964, 34 x 34 cm

Design number 18 showed a pattern composed of elements, continuously reduced by half as they move in the direction of the centre. A similar system of halving was adapted here, but this time moving from within outwards. The limit of the infinitely small shapes is reached on the straight sides of the square.

26. FISHES AND SCALES, woodcut, 1959, 38 x 38 cm

The final example in this group brings in two different sorts of mutation, carried out at one and the same time, that is to say both shape and size. The double process completes itself twice over. In the upper part of the print, from right to left, scales grow into fishes that keep on increasing in size. In the lower half the same thing happens, but from left to right.

27. BUTTERFLIES, wood-engraving, 1950, 28 x 26 cm

Working downwards from the top to the centre, the white area is divided up by black contours of increasing thickness which take on ever larger butterfly shapes; these continue to develop.

e. Story pictures. 28-33

The chief characteristics of the six following prints is the transition from flat to spatial and vice versa. We can think in terms of an interplay between the stiff, crystallised two-dimensional figures of a regular pattern and the individual freedom of three-dimensional creatures capable of moving about in space without hindrance. On the one hand, the members of planes of collectivity come to life in space; on the other, the free individuals sink back and lose themselves in the community. A row of identical spatial beings such as those to be found in the prints of this group often emerges to be treated as a single individual in motion. This is a static method of illustrating a dynamic fact. A few prints from each group, such as 11 (Day en Night), 15 (Liberation) and 17 (Verbum) might also be counted in this category, were it not for the fact that their chief characteristic differs from that of the ones we have just been considering.

28. REPTILES, lithograph, 1943, 33.5 x 38.5 cm

The life cycle of a little alligator. Amid all kinds of objects, a drawing book lies open, and the drawing on view is a mosaic of reptilian figures in three contrasting shades. Evidently one of them has tired of lying flat and rigid amongst his fellows, so he puts one plastic-looking leg over the edge of the book, wrenches himself free and launches out into real life. He climbs up the back of a book on zoology and works his laborious way up the slippery slope of a setsquare to the highest point of his existence. Then after a quick snort, tired but fulfilled, he goes downhill again, via an ashtray, to the level surface, to that flat drawing paper, and meekly rejoins his erstwhile friends, taking up once more his function as an element of surface-division.

N.B. The little book of Job has nothing to do with the Bible, but contains Belgian cigarette papers.

29. CYCLE, lithograph, 1938, 47,5 x 28 cm

At the top right-hand corner a jolly young lad comes popping out of his house. As he rushes downstairs he loses his special quality and takes his place in a pattern of flat, gray, white and black fellow-shapes. Towards the left and upwards these become simplified into lozenges. The dimension of depth is achieved by the combination of three diamonds which give the impression of a cube. The cube is joined on to the house from which the boy emerges. The floor of a terrace is laid with the same familiar pattern of diamond-shaped tiles. The hilly landscape at the top is intended to display the utmost three-dimensional realism, while the periodic pattern at the lower part of the picture shows the greatest possible amount of two-dimensional restriction of freedom.

30. ENCOUNTER, lithograph, 1944, 34 x 46.5 cm

Out from the grey surface of a back wall there develops a complicated pattern of white and black figures of little men. And since men who desire to live need at least a floor to walk on, a floor has been designed for them, with a circular gap in the middle so that as much as possible can still be seen of the back wall. In this way they are forced, not only to walk in a ring but also to meet each other in the foreground: a white optimist and a black pessimist shaking hands with one another.

31. MAGIC MIRROR, lithograph, 1946, 28 x 44,5 cm

On a tiled floor there stands a vertical reflecting screen out of which a fabulous animal is born. Bit by bit it emerges, until a complete beast walks away to the right. His mirror image sets off towards the left, but he seems fairly substantial, for behind the reflecting screen he appears in quite a realistic guise. First of all they walk in a row, then two by two, and finally both streams meet up four abreast. At the same time they lose their plasticity. Like pieces of a jigsaw puzzle they slide into one another, fill up each other's interstices and fade into the floor on which the mirror stands.

32. METAMORPHOSIS, woodcut printed from 29 blocks,

1939-'40 and 1967-'68, 19.5 x 700 cm

A long series of changing shapes. Out of the word "Metamorphose" placed vertically and horizontally on the level surface, with the letter O and M (= Greek E) as points of intersection, there emerges a mosaic of white and black squares that changes into a carpet of flowers and leaves on which two bees have settled. Thereupon the flowers and leaves change back into squares again, only to be transformed once more, this time into animal shapes. To use musical terminology, we are dealing here with four-four time. Now the rhythm changes; a third shade is added to the white and black and the measure changes to three-four time. Each figure becomes simplified and the pattern which at first was composed of squares now consists of hexagons. Then follows an association of ideas; hexagons make one think of the cells in a honeycomb, and so in every cell there appears a bee larve. The fully grown larvae turn into bees which fly off into space. But they are not vouchsafed a long life of freedom, for soon their black silhouettes join together to form a background for white fishes. As these also fuse together, the interstices seem to take on the form of black birds. Similar transformations of background objects now appear several times: dark birds ... light-coloured boats ... dark fishes ... light horses ... dark birds. These become simplified into a pattern of equilateral triangles which serve for a short while as a canvas on which winged letters are depicted but then quickly turn once more into black bird shapes. Small grey birds begin to appear in the white background and than gain in size until their contours equal those of their fellows. Such areas of white that still remain take on the form of a third variety of bird so that there are now three different kinds, each with its own specific form and colour, filling the surface completely. Now for another simplification: each bird turns into a lozenge. Just as in print number 29 ("Cycle"), this is an opportunity to pass over to the three-dimensional, as three diamond-shapes suggest a cube. The blocks give rise to a city on the sea-shore. The tower standing in the water is at the same time a piece in a game of chess; the board for this game, with its light and dark squares, leads back once more to the letters of the word: "Metamorphose".

33. PREDESTINATION, lithograph, 1951, 29 x 42 cm

An agressive, voracious fish and a shy and vulnerable bird are the actors in this drama: such contrasting traits of character lead inevitably to the dénouement. A regular pattern floats like a ribbon in space. Lower down, in the middle, this picturestrip is made up of fishes and birds, but by a substitution of figures, there remain on the left side birds only and on the right fishes. Out from these gradually fading extremities, one representative of each sort breaks loose - a black, devilish fish and a white bird, all innocence, but sad to say irrevocably doomed to destruction. The fate of each is played out in the foreground.

f. Irregular filling of plane surfaces, 34-35

The next two prints consist of figures that do not in any way repeat themselves in similar form. So they do not really belong to group II; nevertheless they were added to it because they do in fact have their surfaces filled up, with no spaces left empty. What is more, they could never have been produced without years of training in regular surface-filling. The recognizability of their components as natural objects plays a more important role. The only reason for their existence is one's enjoyment of his difficult game, without any ulterior motive.

34. MOSAIC I, mezzotint, 1951, 14.5 x 20 cm

Regularity of construction can be recognized in this rectangular mosaic in that, both as regards height and breadth, three light and three dark figures alternate like the squares on a chessboard. With the exception of the shapes round the edge, every white one is surrounded by four black ones and every black by four white. The sum total can immediately be ascertained: 36 pieces, 18 white and 18 black.

35. MOSAIC II, lithograph, 1957, 32 x 37 cm

In this case the only regularity to be noted is the rectangularity of the complete surface. There are but few of the inner figures bordered by four adjacent ones. The direct environment of the frog consists of two figures; the guitar is hemmed in by three, the cock by five and the ostrich (if that is what it really is) by six. The sum total can only be arrived at by careful counting.

III. UNLIMITED SPACES. 36-37-38

36. THREE INTERSECTING PLANES, woodcut printed from two blocks, 1954, 32.5 x 37.5 cm

Three planes intersect each other at right angles. They are indicated by square tiles with the same number of square gaps between them. Each plane recedes in perspective to a vanishing point and the three vanishing points coincide with the points of an equilateral triangle.

37. CUBIC SPACE-DIVISION, lithograph, 1952, 27 x 26.5 cm

Intersecting each other at right angles, girders divide each other into equal lengths, each forming the edge of a cube. In this way space is filled to infinity with cubes of the same size.

38. DEPTH, wood-engraving printed from 3 blocks, 1955, 32 x 23 cm

Here too, space is divided up cubically. Each fish is found at the intersection of three lines of fish all of which cross each other at right-angles

IV. SPATIAL RINGS AND SPIRALS. 39-46

39. KNOTS, woodcut printed from 3 blocks, 1965, 43 x 32 cm

Three unbroken knots are here displayed; that is to say three times over a simple knot has been tied in a cord the ends of which run into each other. The perpendicular cross-section of each knot is different. In the top righthand example the profile is round, as in a sausage; the top left one is cruciform, with two flat bands intersecting each other at right angles; below is a square, hollow pipe with gaps through which the inside can be seen. If we start at any arbitrary point and follow a flat wall with the eye, then it appears that we have to make four rounds before we come back to our point of departure. So the pipe does not consist of four separate strips but of one, which runs through the knot four times. The knot shown at the top righthand corner is in principle every bit as interesting, but it remains undiscussed here, as the draughtsman hopes to devote a more detailed print to it in the future

40. MOEBIUS STRIP II, woodcut, printed from 3 blocks, 1963, 45 x 20 cm

An endless ring-shaped band usually has two distinct surfaces. one inside and one outside. Yet on this strip nine red ants crawl after each other and travel the front side as well as the reverse side. Therefore the strip has only one surface.

41. MOEBIUS STRIP I, wood-engraving printed from 4 blocks, 1961. 24 x 26 cm

An endless band has been cut through, down its whole length. The two sections have been drawn apart from each other a little, so that a clear space divides them all the way round. Thus the band ought to fall apart into two unattached rings, and yet apparently it consists of one single strip, made up of three fishes, each biting the tail of the one in front. They go round twice before regaining their point of departure.

42. SPIRALS, wood-engraving printed from 2 blocks, 1953, 27 x 33.5 cm

Four spiralling strips come together to form a curved casing which, as a narrowing torus, returns to the place where it began, penetrates within itself and starts on its second round.

43. SPHERE SPIRALS, woodcut printed from 4 blocks, 1958, diameter 32 cm

Here, just as in no. 20, a sphere is shown with a network of longitudinal and latitudinal circles. Four spirals twist their way around the spherical surface infinitely small at the poles and broadest at the equator. Half of its yellow exterior is visible. Through open lanes in its side the red interior can be followed to the opposite pole.

44. CONCENTRIC RINDS, wood-engraving, 1953, 24 x 24 cm

Four spherical concentric rinds are illuminated by a central source of light. Each rind consists of a network of nine large circles which divide the surface of the sphere into forty-eight similarshaped spherical triangles.

45. RIND, wood-engraving printed from 4 blocks, 1955,

34.5 x 23.5 cm

Like the spirally shaped peel of a fruit and like a hollow, fragmented sculpture, the image of a women floats through space. The sense of depth is enhanced by a bank of clouds which diminishes towards the horizon.

46. BOND OF UNION, lithograph, 1956, 26 x 34 cm

Two spirals merge and portray, on the left, the head of a woman and, on the right, that of a man. As an endless band, their foreheads intertwined, they form a double unity. The suggestion of space is magnified by spheres which float in front of, within and behind the hollow images.

V. MIRROR IMAGES. 47-54

a. Reflections in water. 47-48-49

47. RIPPLED SURFACE, lino-cut printed from 2 blocks, 1950, 26 x 32 cm

Two raindrops fall into a pond and, with the concentric, expanding ripples that they cause, disturb the still reflexion of a tree with the moon behind it. The rings shown in perspective afford the only means whereby the receding surface of the water is indicated.

48. THREE WORLDS, lithograph, 1955, 36 x 25 cm

This picture of a woodland pond is made up of three elements: the autumn leaves which show the receding surface of the water, the reflexion of three trees in the background and, in the foreground, the fish seen through the clear water.

49. PUDDLE, woodcut printed from 3 blocks, 1952, 24 x 32 cm The cloudless evening sky is reflected in a puddle which a recent shower has left in a woodland path. The tracks of two motor cars, two bicycles and two pedestrians are impressed in the soggy ground.

b. Sphere reflexions. 50-54

50. STILL LIFE WITH REFLECTING GLOBE, lithograph, 1934, 28.5 x 32.5 cm

The same reflecting globe as the one shown in no. 51, Hand with Reflecting Globe, but in this case viewed sideways on, like a bottle with a neck.

51. HAND WITH REFLECTING GLOBE, lithograph, 1935,

32 x 21.5 cm

A reflecting globe rests in the artist's hand. In this mirror he can have a much more complete view of his surroundings than by direct observation, for nearly the whole of the area around him four walls, the floor and ceiling of his room — are compressed, albeit distorted, within this little disc. His head, or to be more precise the point between his eyes, comes in the absolute centre. Whichever way he turns he remains at the centre. The ego is the unshakable core of his world.

52. THREE SPHERES II, lithograph, 1946, 26 x 47 cm

Three spheres, of equal size but different in aspect, are placed next to each other on a shiny table. The one on the left is made of glass and filled with water, so it is transparent but also reflects. It magnifies the structure of the table top on which it rests and at the same time mirrors a window. The righthand sphere, with its matt surface, presents a light side and dark side more clearly than the other two. The attributes of the middle one are the same as those described in connection with no. 51; the whole of the surrounding area is reflected in it. Furthermore it achieves, in two different ways, a triple unity, for not only does it reflect its companions to left and right, but all three of them are shown in the drawing on which the artist is working.

53. DEWDROP, mezzotint, 1948, 18 x 24.5 cm

This leaf from a succulent plant was in fact about 1 inch in length. On it lies a dewdrop which shows a reflection of a window and yet at the same time serves as a lens which magnifies the structure of the leaf-veins. Quaintly shaped air-pockets, shining white, are trapped between the leaf and the dewdrop.

54. EYE, mezzotint, 1946, 15 x 20 cm

Here the artist has drawn his eye, greatly enlarged, in a concave shaving mirror. The pupil reflects the one who watches us all.

VI. INVERSION. 55-56

It was stated in connection with print no. 29 that a combination of three diamond-shapes can make a cube. Yet it still remains an open question as to whether we are looking at this cube from within or without. The mental reversal, this inward or outward turning, this inversion of a shape, is the game that is played in the two following prints. 55. CUBE WITH MAGIC RIBBONS, lithograph, 1957, $31 \times 31 \text{ cm}$ Two endless circular bands, fused together in four places, are curved around the diagonals of a cube. Each strip has a row of button-like protuberances. If we follow one of these series with the eye, then these nodules surreptitiously change from convex to concave.

56. CONVEX AND CONCAVE, lithograph, 1955, 28 x 33.5 cm Three little houses stand near one another, each under a crossvaulted roof. We have an **ex**terior view of the left-hand house, an **in**terior view of the right-hand one and an either exterior view or interior view of the one in the middle, according to choice. There are several similar inversions illustrated in this print; let us describe one of them. Two boys are to be seen, playing a flute. The one on the left is looking down through a window on to the roof of the middle house; if he were to climb out of the window he could stand on this roof. And then if he were to jump down in front of it he would land up one storey lower, on the darkcoloured floor before the house. And yet the right-hand flute-player who regards that same cross-vault as a roof curving above his head, will find, if he wants to climb out of **his** window, that there is no floor for him to land on, only a fathomless abyss.

VII. POLYHEDRONS. 57-62

57. DOUBLE PLANETOID, wood-engraving, printed from 4 blocks, 1949, diameter 37.5 cm

Two regular tetrahedrons, piercing each other, float through space as a planetoid. The light-coloured one is inhabited by human beings who have completely transformed their region into a complex of houses, bridges and roads. The darker tetrahedron has remained in its natural state, with rocks, on which plants and prehistoric animals live. The two bodies fit together to make a whole but they have no knowledge of each other.

58. TETRAHEDRAL PLANETOID, woodcut printed from 2 blocks, 1954, 43 x 43 cm

This little planet inhabited by humans has the shape of a regular tetrahedron and is encircled by a spherical atmosphere. Two of the four triangular surfaces, with which this body is faced, are visible. The edges which separate them divide the picture into two. All the vertical lines: the walls, houses, trees and people, point in the direction of the core of the body — its centre of gravity — and all the horizontal surfaces, gardens, roads, stretches of water in pools and canals, are parts of a spherical crust.

59. ORDER AND CHAOS, lithograph, 1950, 28 x 28 cm

A stellar dodecahedron is placed in the centre and is enclosed in a translucent sphere like a soap bubble. This symbol of order and beauty reflects the chaos in the shape of a heterogeneous collection of all sorts of useless, broken and crumpled objects.

60. GRAVITY, lithograph, coloured by hand, 1952, 30 x 30 cm

Here once again is a stellar dodecahedron, encased in twelve flat, five-pointed stars. On each of these platforms lives a tail-less monster with a long neck and four legs. He sits there with his rump caught beneath a flat-side pyramid each wall of which has an opening, and through this opening the creature sticks his head and legs. But the pointed extremety of one animal's dwellingplatform is at the same time the wall of one of his fellow-sufferer's prisons. All these triangular protrusions function both as floors and as walls; so it comes about that this print, the last in the series of polyhedrons, serves also as a transition to the relativity group.

61. STARS, wood-engraving, 1948, 32 x 26 cm

Single, double and triple regular bodies float like stars through space. In the midst of them is a system of three regular octahedrons, indicated by their edges only. Two chameleons have been chosen as denizens of this framework, because they are able to cling by their legs and tails to the beams of their cage as it swirls through space.

62. FLAT WORMS, lithograph, 1959, 34 x 41.5 cm

Bricks are usually rectangular, because in that way they are most suitable for building the vertical walls of our houses. But anyone who has to do with the stacking of stones of a non-cubic type will be well aware of other possibilities. For instance, one can make use of tetrahedrons alternating with octahedrons. Such are the basic shapes which are used to raise the building illustrated here. They are not practicable for human beings to build with, because they make neither vertical walls nor horizontal floors. However, when this building is filled with water, flatworms can swim in it.

VIII. RELATIVITIES. 63-67

The underlying idea in the following pictures is basically this: before photography was invented, perspective was always closely linked with horizon. Yet even at the time of the Renaissance it was known that not only do the horizontal lines of a building meet at a point on the horizon (the famous "vanishing point"), but also the vertical lines meet downwards at the nadir and upwards at the zenith. This is obvious with old ceiling-paintings which have vertical perspective receding lines, such as pillars. But now that photography is part of our everyday lives, we really have come to understand vertical perspective. We have only to point our lens at the top or at the bottom of a building to realize that architectural draughtsmen are simply taking the easy way out when they indicate everything that stands vertically, in their perspective projections, with parallel lines. In the following prints the vanishing point has several different functions at one and the same time. Sometimes it is situated on the horizon, the nadir and the zenith all at once.

63. ANOTHER WORLD, wood-engraving printed from 3 blocks, 1947, 31.5 x 26 cm

The interior of a cube-shaped building. Openings in the five visible walls give views of three different landscapes. Through the topmost pair one looks down, almost vertically, on to the ground; the middle two are at eye-level and show the horizon, while through the bottom pair one looks straight up to the stars. Each plane of the building, which unites nadir, horizon and zenith, has a threefold-function. For instance, the rear plane in the centre serves as a **wall** in relation to the horizon, a **floor** in connection with the view through the top opening and a **ceiling** so far as the view up to towards the starry sky is concerned.

64. HIGH AND LOW, lithograph, 1947, 50.5 x 20.5 cm

In this print the same picture is presented twice over, but viewed from two different points. The upper half shows the view that an observer would get if he were about three storeys up; the lower half is the scene that would confront him if he were standing at ground level. If he should take his eyes off the latter and look upwards, then he would see the tiled floor on which he is standing, repeated as a ceiling in the centre of the composition. Yet this acts as a floor for the upper scene. At the very top, this tiled floor repeats itself once again, purely as a ceiling.

65. CURL-UP, lithograph, 1951, 17 x 23.5 cm

The imaginary creature here portrayed and fully described goes into action in the following print.

"The Pedalternorotandomovens centroculatus articulosus came into being (generatio spontanea!) as a result of dissatisfaction concerning nature's lack of any wheelshaped living creatures endowed with the power of propulsion by means of rolling themselves up. So the little animal shown here, know in popular parlance as the 'curl-up' or 'sausage roll', is an attempt to fill a long-felt want. Biological details are still scarce; is it a mammal, a reptile or an insect? It has a protracted body made up of horny articulated sections, and three pairs of legs the extremities of which resemble the human foot. Placed centrally in the thick, round head (shaped like an acutely curved parrot's beak), are the bulging eyes, on the ends of stalks and sticking far out on either side. In its fully stretched position this creature can move slowly and gingerly forward, by using its six legs, over allmost any type of terrain (it can, if occasion arises, climb up or down steeps, stairways, penetrate undergrowth or clamber over chunks of rock). But as soon as it needs to undertake a long journey and has the advantage of a suitable level path for the purpose, it presses its head on the ground and rolls itself up with lightening speed, pushing itself with its legs, in so far as they touch the ground.

In its rolled-up position, it has the shape of a discus, the central axis formed by the eyes on stalks. By pushing out each of its pairs of legs in turn it can get up a high speed. Furthermore, it is thought to be capable of retracting its legs and freewheeling onwards (for instance when coming down a slope or going full tilt). Whenever it has reason to do so, it is able to return to its walking position by one of two methods: (i) an abrupt stop brought about by suddenly stretching its body, in which case it ends up on its back with its legs in the air; (ii) a gradual reduction of speed, using the legs as brakes and coming to a halt by slowly unrolling backwards."

66. HOUSE OF STAIRS, lithograph, 1951, 47 x 24 cm

Now comes a further development of the concept of relativity that was displayed in the foregoing prints. A playful element is introduced, one which came up for discussion in connection with the regular dividing-up of surfaces, in other words glide reflexion. Roughly the whole of the top half of the print is the mirror image of the bottom half. The topmost flight of steps, down which a curl-up is crawling from left to right, is reflected twice over, once in the middle and then again in the lower part. On the stairs in the top right-hand corner, in the same way as is also shown in number 67, the distinction between ascending and descending is eliminated, for two rows of animals are moving side by side, yet one row is going up and the other down.

67. RELATIVITY, lithograph, 1953, 28 x 29 cm

Here we have three forces of gravity working perpendicularly to one another. Three earth-planes cut across each other at rightangles, and human beings are living on each of them. It is impossible for the inhabitants of different worlds to walk or sit or stand on the same floor, because they have differing conceptions of what is horizontal and what is vertical. Yet they may well share the use of the same **staircase**. On the top staircase illustrated here, two people are moving side by side and in the same direction, and yet one of them is going downstairs and the other upstairs. Contact between them is out of the question, because they live in different worlds and therefore can have no knowledge of each other's existence.

IX. CONFLICT BETWEEN THE FLAT AND THE SPATIAL. 68-73

Our three-dimensional space is the only true reality that we know. The two-dimensional is every bit as fictitious as the four-dimensional, for nothing is flat, not even the most finely polished mirror. And yet we stick to the convention that a wall or a piece of paper is flat, and curiously enough, we still go on, as we have done since time immemorial, producing illusions of space on just such plane surfaces as those. Surely it is a bit absurd to draw a few lines and then claim: "This is a house". This odd situation is the theme of the next five pictures.

68. THREE SPHERES I, wood-engraving, 1945, 28 x 17 cm

At the top of this print the spatial nature of a globe is brought out as strongly as possible. Yet it is not a globe at all, merely the projection of one on a piece of paper which could be cut out as a disc. In the middle, just such a paper disc is illustrated, but folded in two halves, one part vertical and the other horizontal, with the top sphere resting on this latter. At the bottom another such disc is shown, but unfolded this time, and seen in perspective as a circular table top.

69. DRAWING HANDS, lithograph, 1948, 28.5 x 34 cm

A piece of paper is fixed to a base with drawing pins. A right hand is busy sketching a shirt-cuff upon this drawing paper. At this point its work is incomplete but a little further to the right it has already drawn a left hand emerging from a sleeve in such detail that this hand has come right up out of the flat surface, and in its turn it is sketching the cuff from which the right hand is emerging, as though it were a living member.

70. BALCONY, lithograph, 1945, 30 x 23.5 cm

The spatial nature of these houses is a fiction. The two-dimensional nature of the paper on which it is drawn is not disturbed — unless we give it a bang from behind. But the bulge that can be seen in the centre is an illusion too, for the paper stays flat. All that has been achieved is an expansion, a quadruple magnification in the centre.

71. DORIC COLUMNS, wood-engraving printed from three blocks, 1945, 32 x 24 cm

The lower part of the left-hand column suggests a heavy threedimensional stone object, and yet it is nothing more than a bit of ink on a piece of paper. So it turns out to be a flat strip of paper which, having been folded three times, has got itself jammed between the ceiling and the capital of the righthand column. But the same thing applies to the righthand column itself; from above it resembles a ribbon lying flat on the floor with the lefthand column resting upon it.

72. PRINT GALLERY, lithograph, 1956, 32 x 32 cm

As a variation on the theme of the print Balcony, namely, magnification towards the centre, we have here an expansion which curves around the empty centre in a clockwise direction. We come in through a door on the lower right to an exhibition gallery where there are prints on stands and walls. First of all we pass a visitor with his hands behind his back and then, in the lower left-hand corner, a young man who is already four times as big. Even his head has already expanded in relation to his hand. He is looking at the last print in a series on the wall and glancing at its details; the boat, the water and the houses in the background. Then his eye moves further on from left to right, to the ever expanding blocks of houses. A woman looks down through her open window on to the sloping roof which covers the exhibition gallery; and this brings us back to where we started our circuit. The boy sees all these things as two-dimensional details of the print that he is studying. If his eye explores the surface further then he sees himself as a part of the print.

73. DRAGON, wood-engraving, 1952, 32 x 24 cm

However much this dragon tries to be spatial, he remains completely flat. Two incisions are made in the paper on which he is printed. Then it is folded in such a way as to leave two square openings. But this dragon is an obstinate beast, and in spite of his two-dimensions he persists in assuming that he has three; so he sticks his head through one of the holes and his tail through the other

X. IMPOSSIBLE BUILDINGS. 74-75-76

74. BELVEDERE, lithograph, 1958, 46 x 29.5 cm

In the lower left foreground there lies a piece of paper on which the edges of a cube are drawn. Two small circles mark the places where edges cross each other. Which edge comes at the front and which at the back? In a three-dimensional world simultaneous front and back is an impossibility and so cannot be illustrated. Yet it is quite possible to draw an object which displays a different reality when looked at from above and from below. The lad sitting on the bench has got just such a cube-like absurdity in his hands. He gazes thoughtfully at this incomprehensible object and seems oblivious to the fact that the belvedere behind him has been built in the same impossible style. On the floor of the lower platform, that is to say indoors, stands a ladder which two people are busy climbing. But as soon as they arrive a floor higher they are back in the open air and have to re-enter the building. Is it any wonder that nobody in this company can be bothered about the fate of the prisoner in the dungeon who sticks his head through the bars and bemoans his fate?

75. ASCENDING AND DESCENDING, lithograph, 1960, 38 x 28.5 cm The endless stairs which are the main motif of this picture were taken from an article by L.S. and R. Penrose in the February, 1958 issue of the British Journal of Psychology. A rectangular inner courtyard is bounded by a building that is roofed in by an neverending stairway. The inhabitants of these living-quarters would appear to be monks, adherents of some unknown sect. Perhaps it is their ritual duty to climb those stairs for a few hours each day. It would seem that when they get tired they are allowed to turn about and go downstairs instead of up. Yet both directions, though not without meaning, are equally useless. Two recalcitrant individuals refuse, for the time being, to take any part in this exercise. They have no use for it at all, but no doubt sooner or later they will be brought to see the error of their nonconformity.

76. WATERFALL, lithograph, 1961, 38 x 30 cm

In the same article in the British Journal of Psychology as was mentioned in connection with the foregoing print, R. Penrose publishes the perspective drawing of a triangle. A copy of this is reproduced here. It is composed of square beams which rest upon each other at right-angles. If we follow the various parts of this construction one by one we are unable to discover any mistake in it. Yet it is an impossible whole because changes suddenly occur in the interpretation of distance between our eye and the object. This impossible triangle is fitted three times over into the picture. Falling water keeps a millwheel in motion and subsequently flows along a sloping channel between two towers, zigzagging down to the point where the waterfall begins again. The miller simply needs to add a bucketful of water from time to time, in order to compensate for loss through evaporation. The two towers are the same height and yet the one on the right is a storey lower than the one on the left.

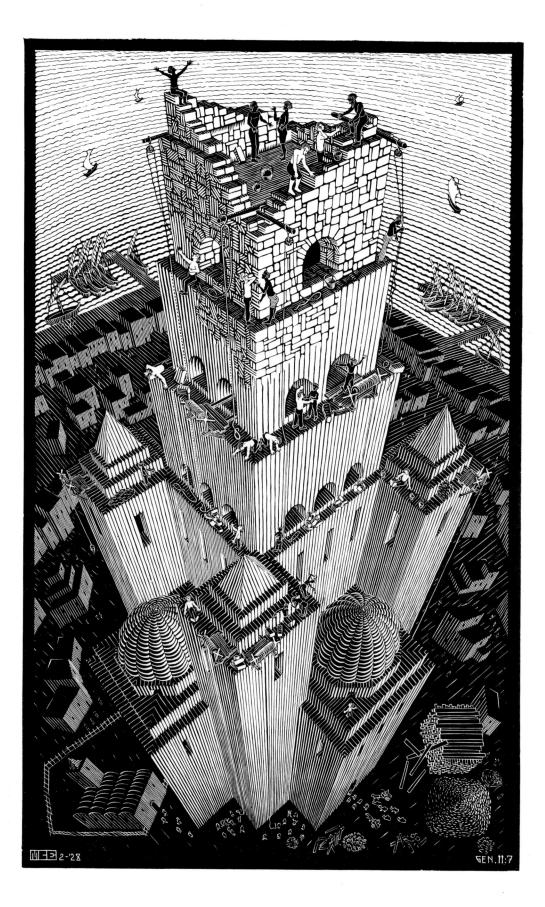

1. Toren van Babel - Tower of Babel - Turm von Babel - Tour de Babel

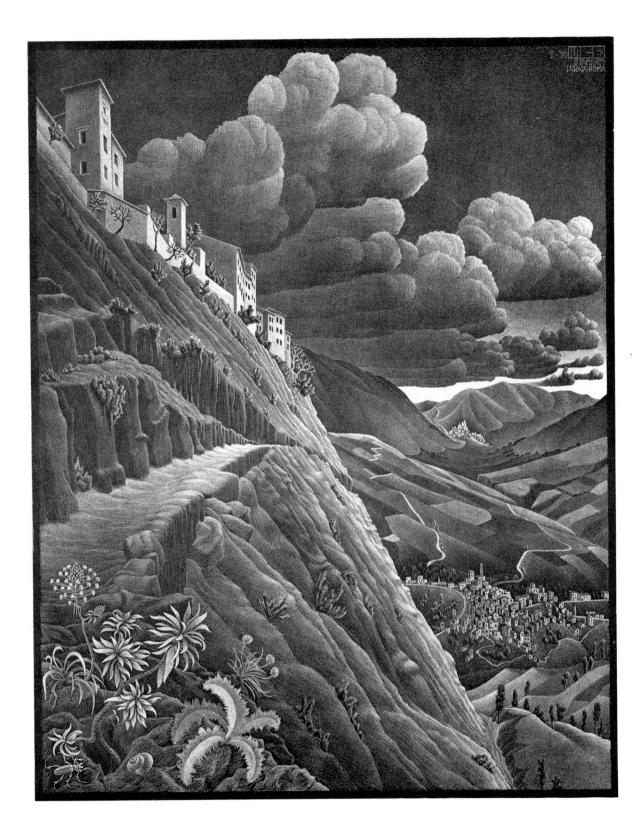

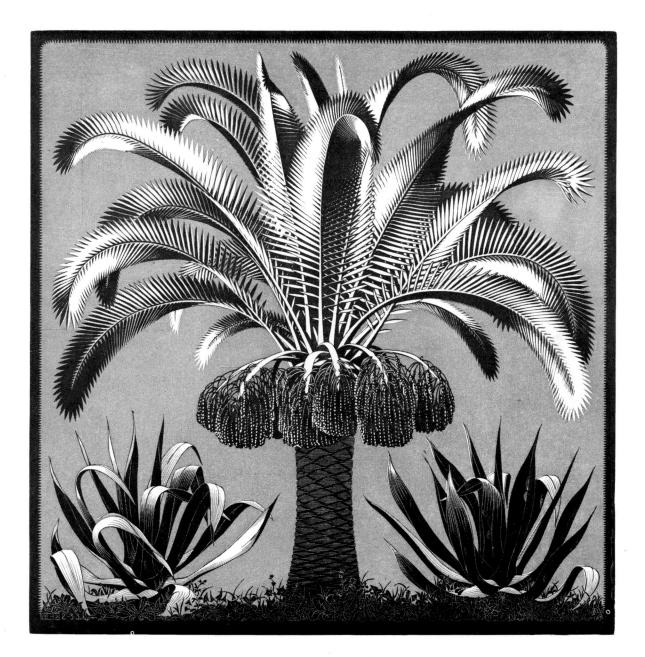

3. Palm - Palm - Palme - Palmier

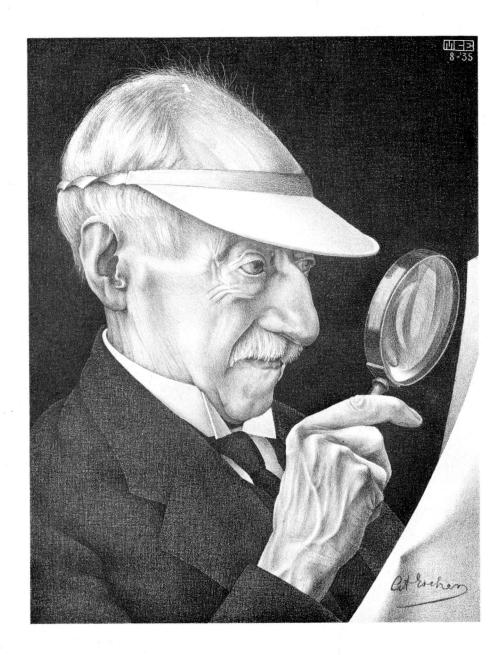

4. G. A. Escher

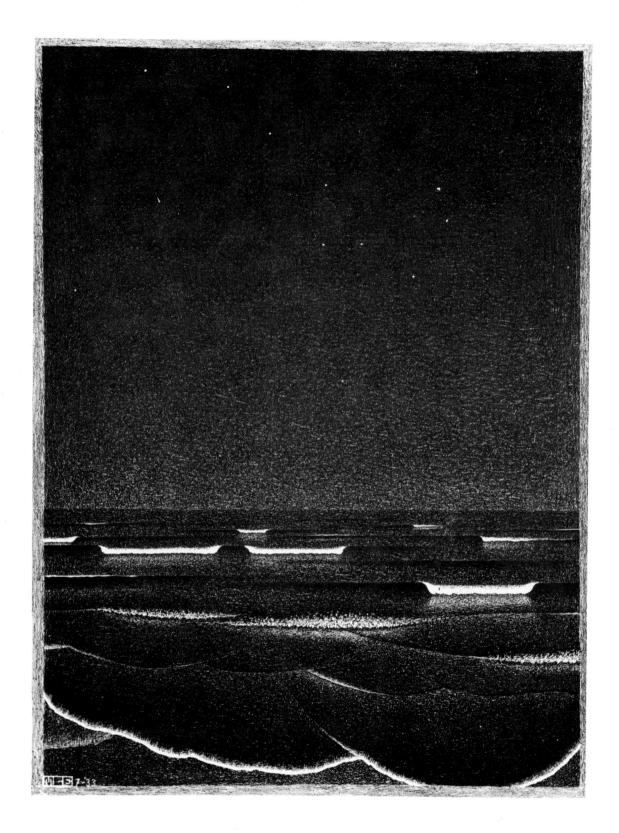

5. Lichtende zee - Fluorescent sea - Leuchtendes Meer - Mer phosphorescente

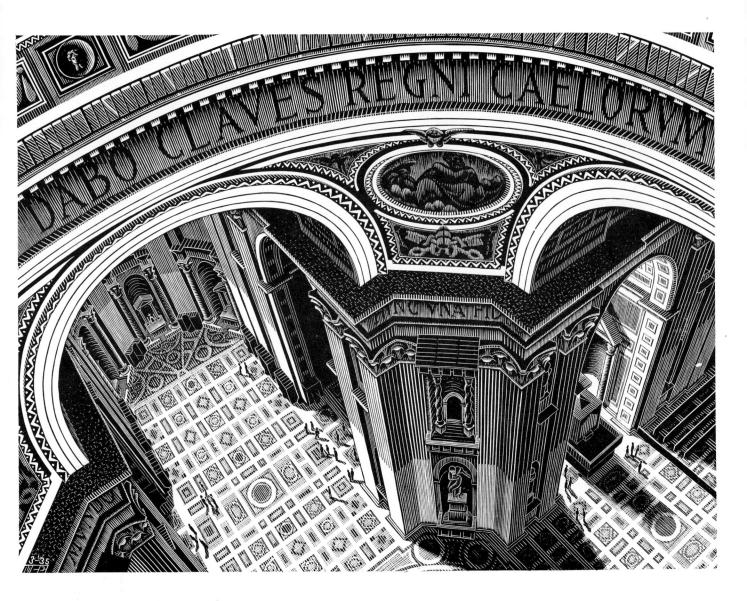

6. St. Pieter, Rome - St. Peter, Rome - St. Peter, Rom - St. Pierre, Rome

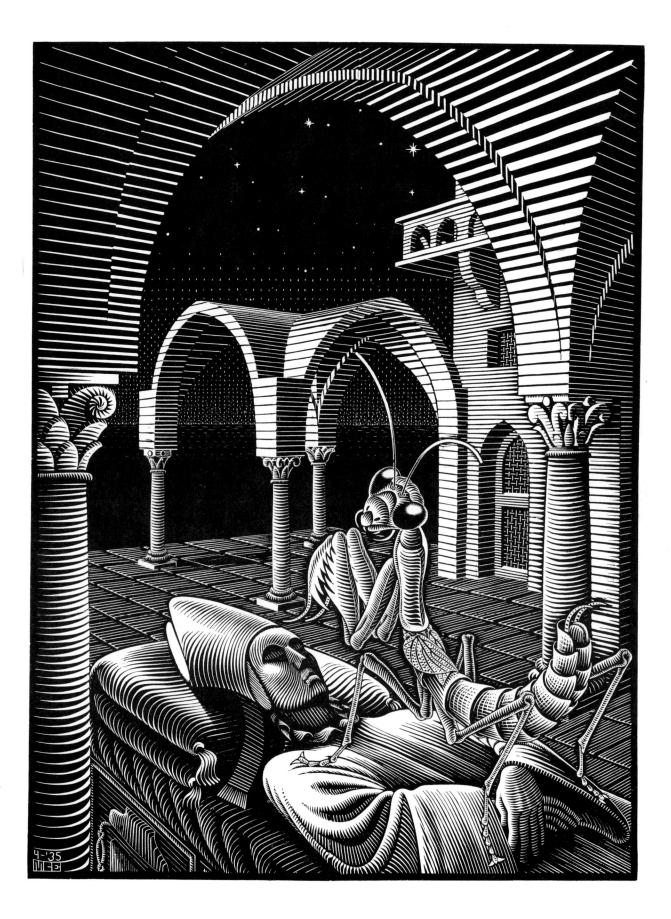

7. Droom - Dream - Traum - Rêve

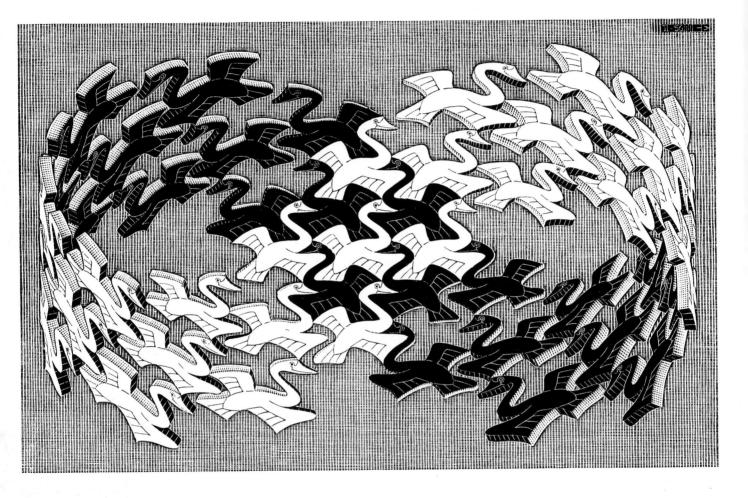

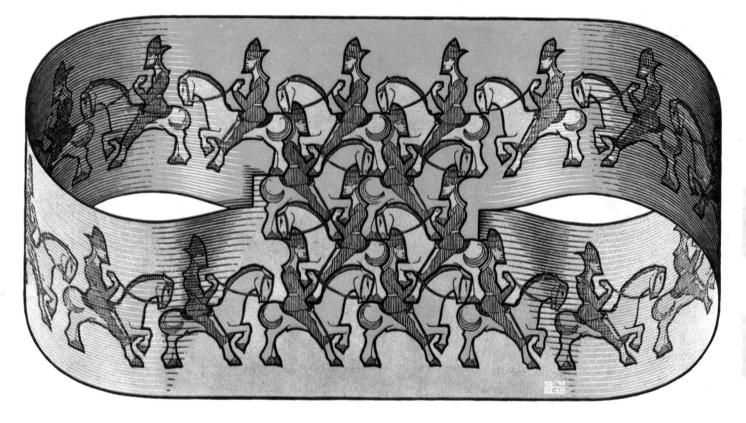

9. Ruiter - Horseman - Reiter - Cavalier

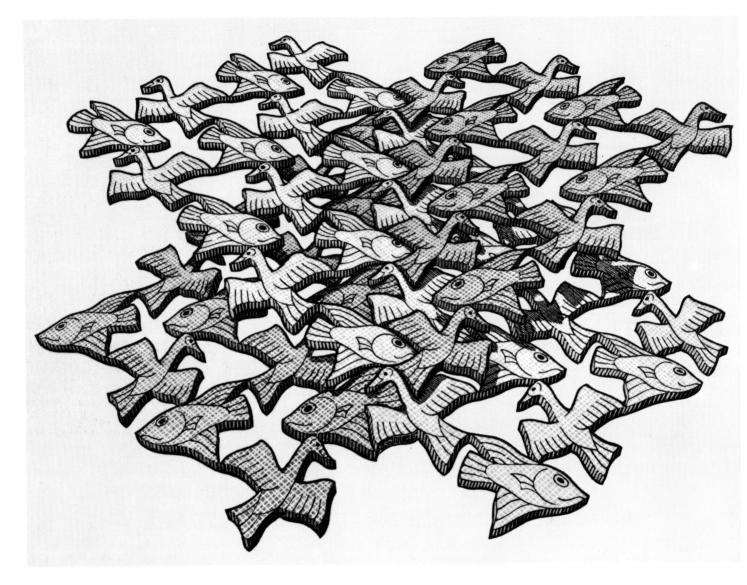

10. Twee snijdende vlakken - Two intersecting planes - Zwei sich schneidende Flächen -Intersection de deux plans

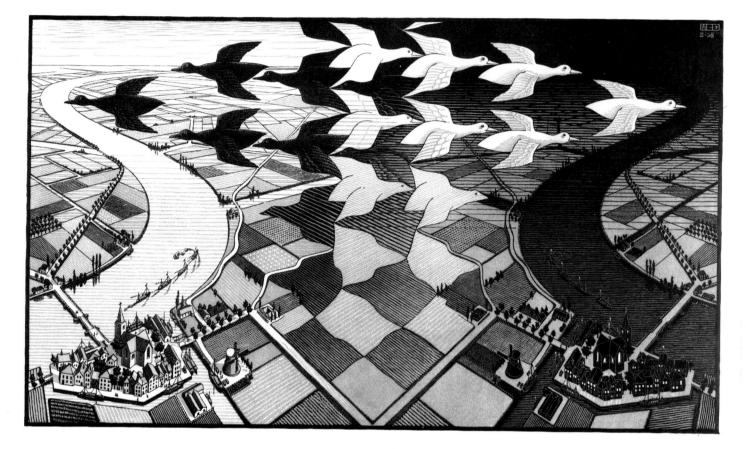

11. Dag en nacht - Day and night - Tag und Nacht - Jour et nuit

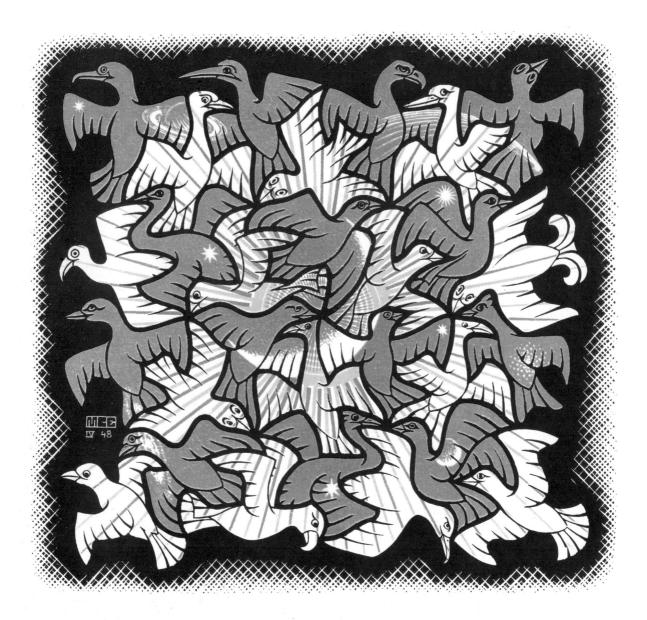

12. Zon en maan - Sun and moon - Sonne und Mond - Le soleil et la lune

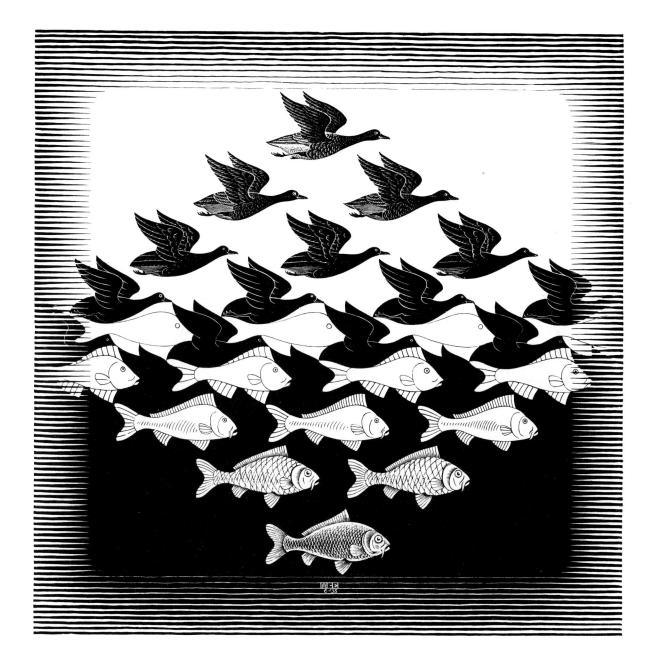

13. Lucht en water I - Sky and water I - Luft und Wasser I - Le ciel et la mer I

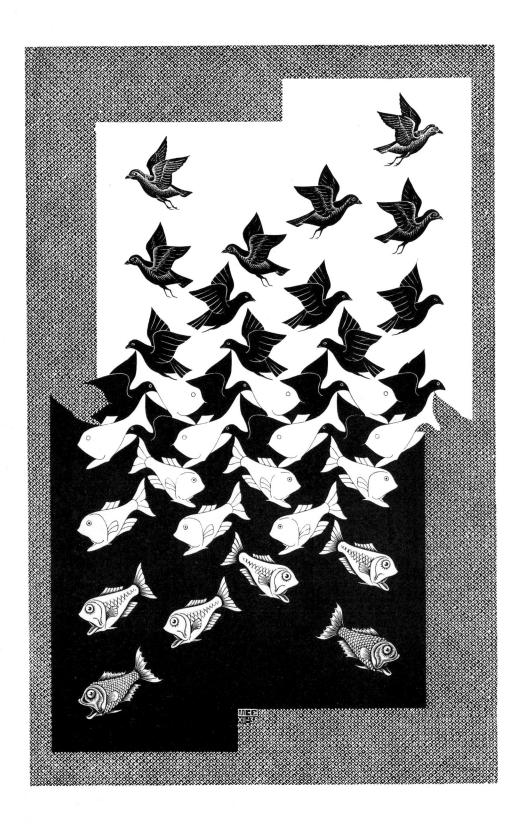

14. Lucht en water II - Sky and water II - Luft und Wasser II - Le ciel et la mer II

15. Bevrijding - Liberation - Befreiung - Délivrance

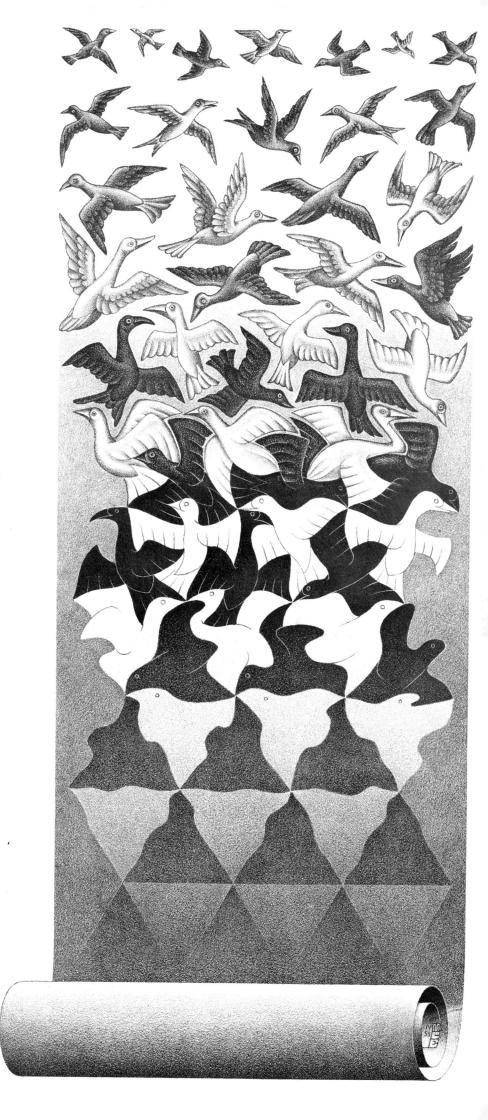

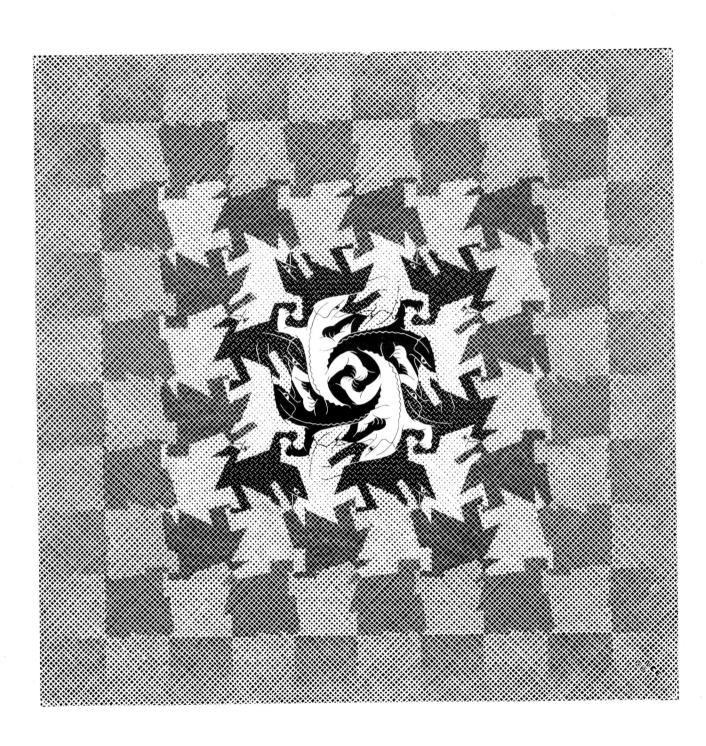

16. Ontwikkeling I - Development I - Entwicklung I - Développement I

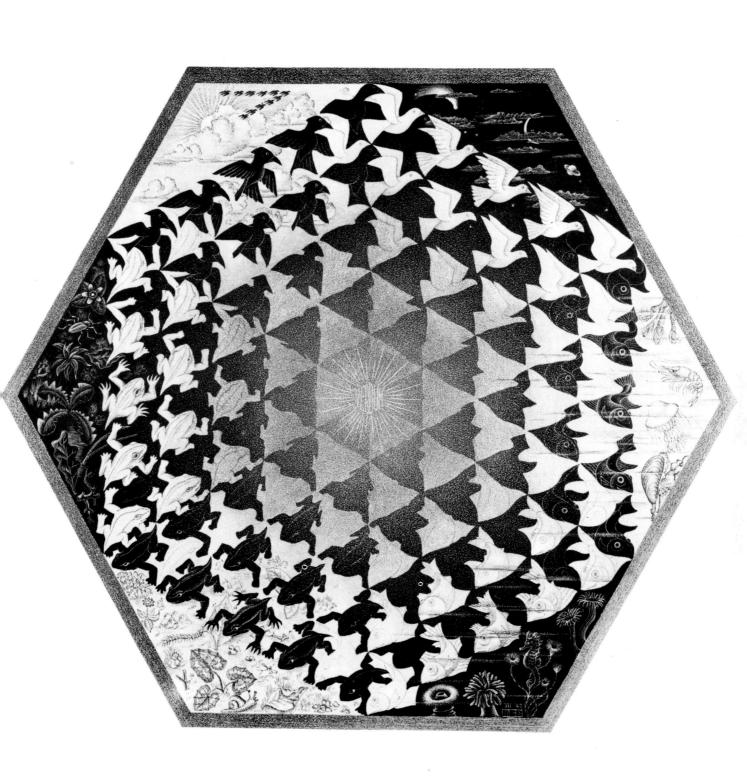

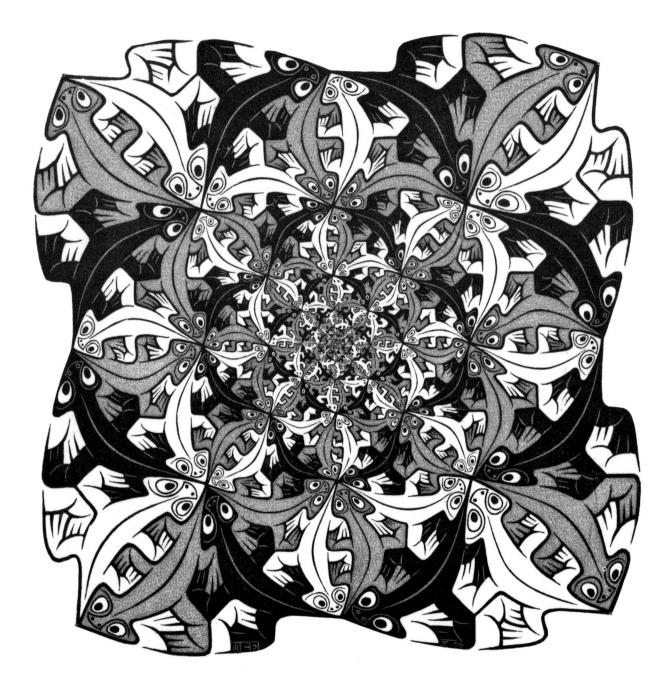

18. Kleiner en kleiner - Smaller and smaller - Kleiner und kleiner - De plus en plus petit

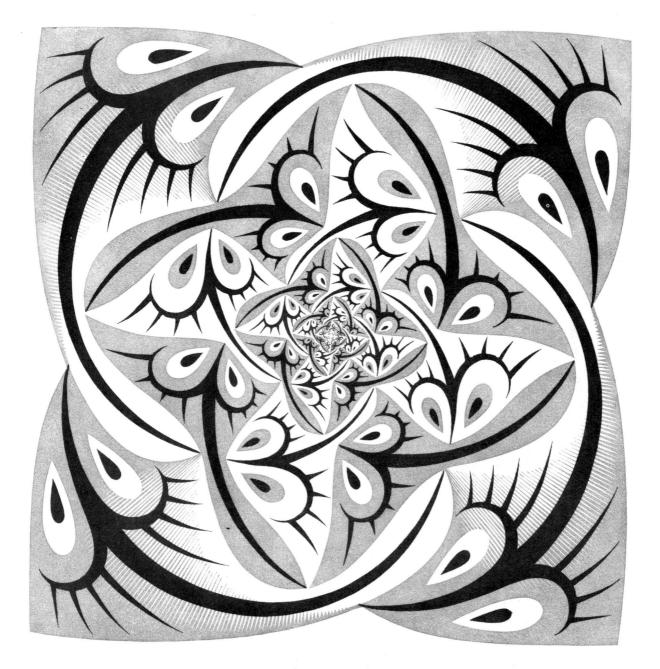

19. Levensweg II - Path of life II - Lebensweg II - Chemin de la vie II

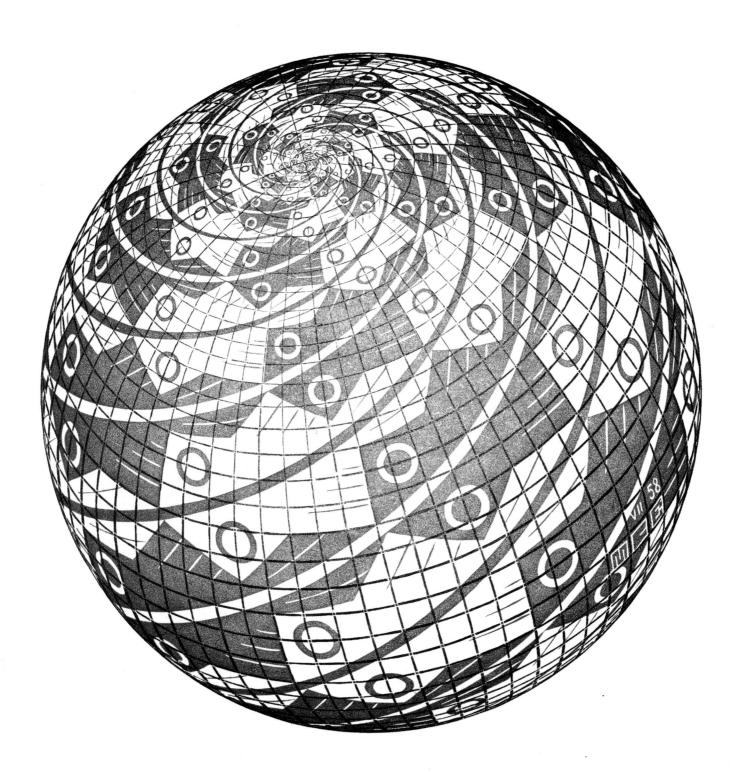

20. Boloppervlak met vissen - Sphere surface with fishes - Kugeloberfläche mit Fischen -Surface sphérique avec poissons

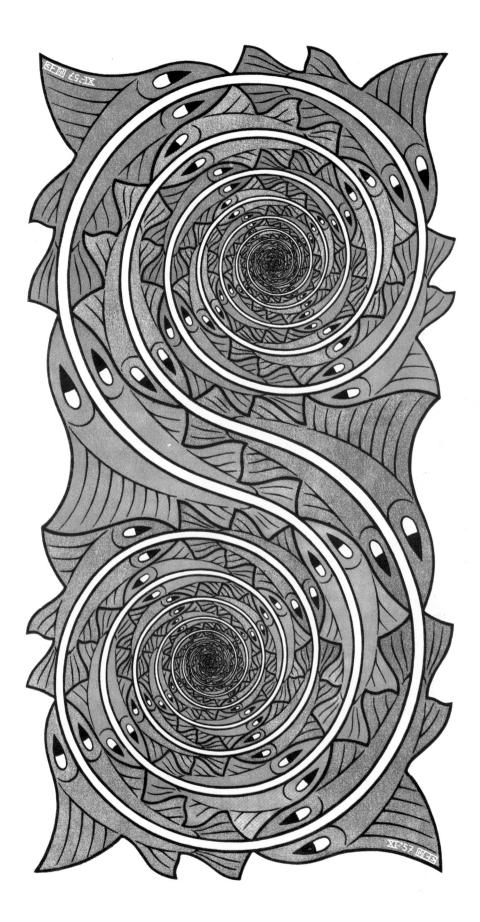

21. Draaikolken - Whirlpools - Drehstrudel - Tourbillons

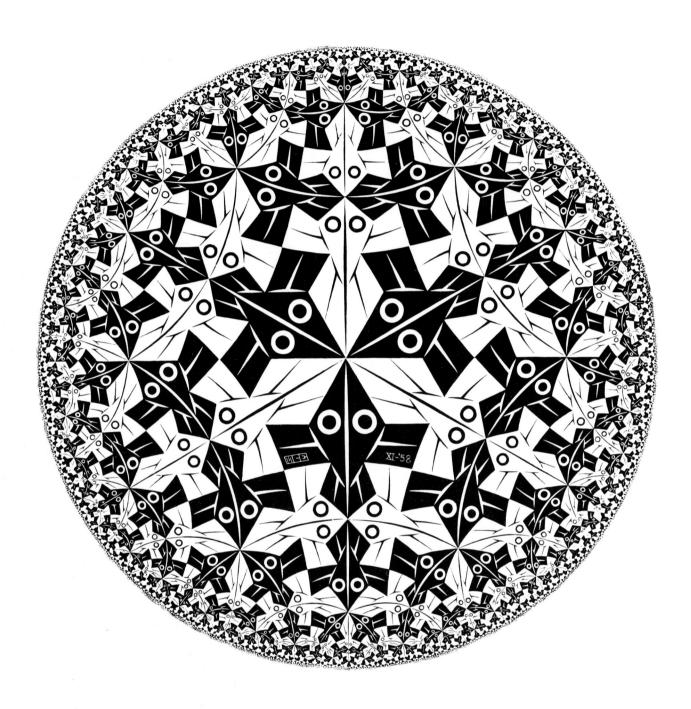

22. Cirkellimiet I - Circle limit I - Kreislimit I - Limite circulaire I

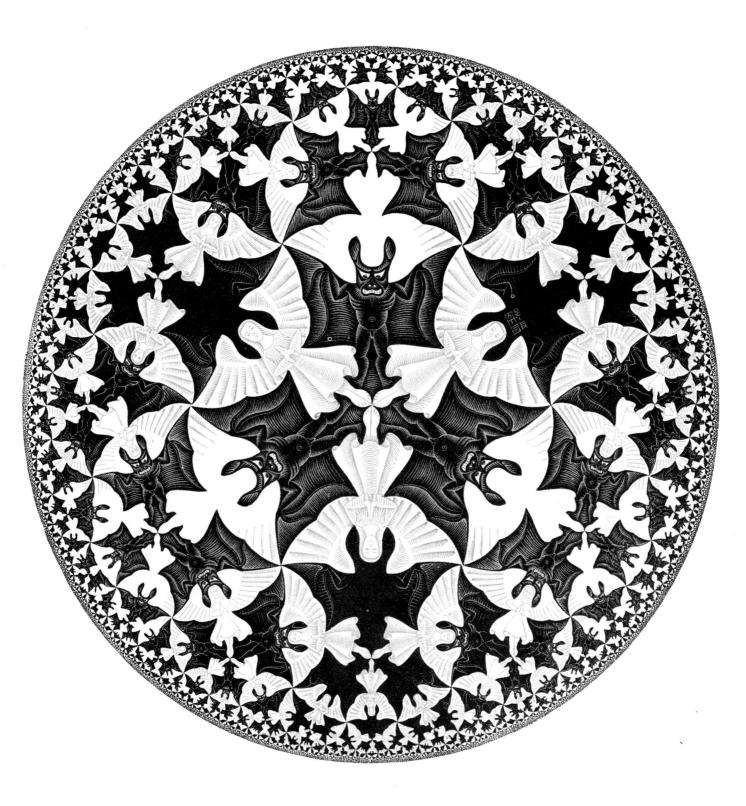

23. Cirkellimiet IV - Circle limit IV - Kreislimit IV - Limite circulaire IV

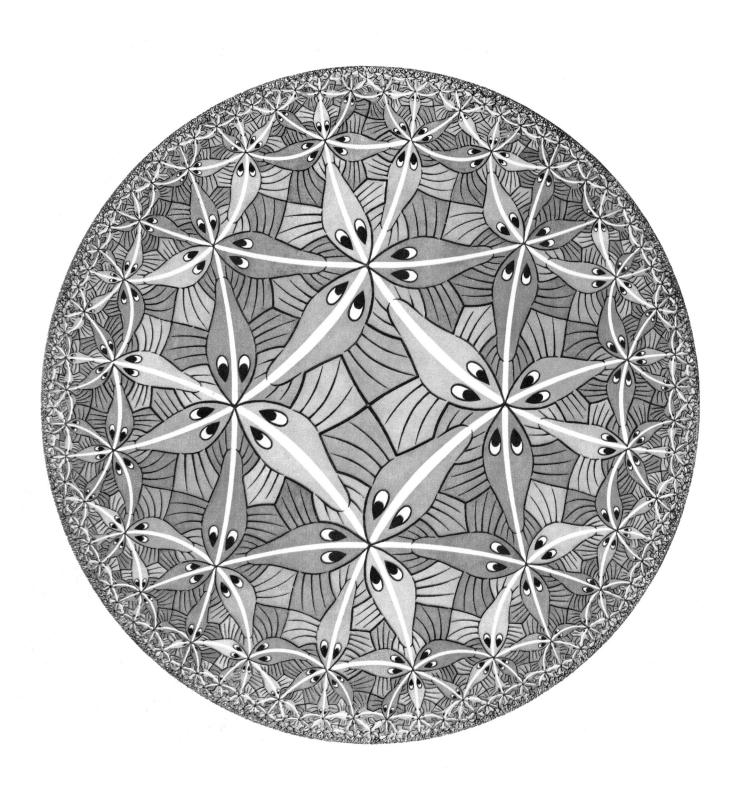

24. Cirkellimiet III - Circle limit III - Kreislimit III - Limite circulaire III

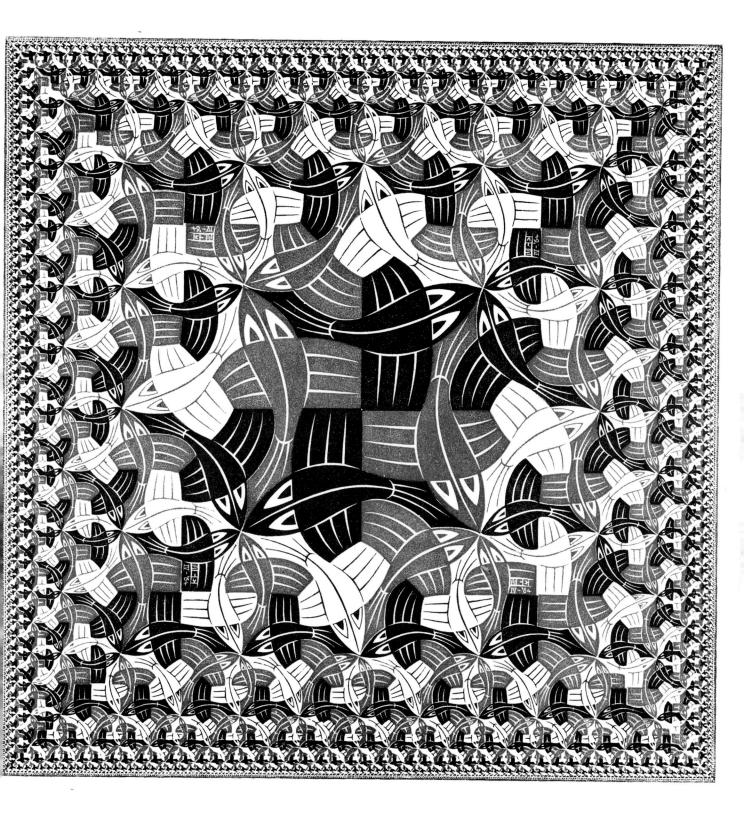

25. Vierkantlimiet - Square limit - Quadratlimit - Limite carrée

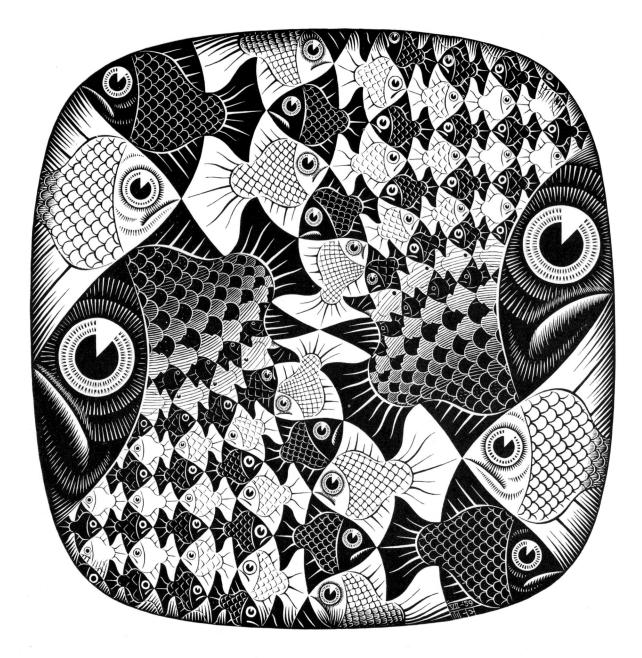

26. Vissen en schubben - Fishes and scales - Fische und Schuppen - Poissons et écailles

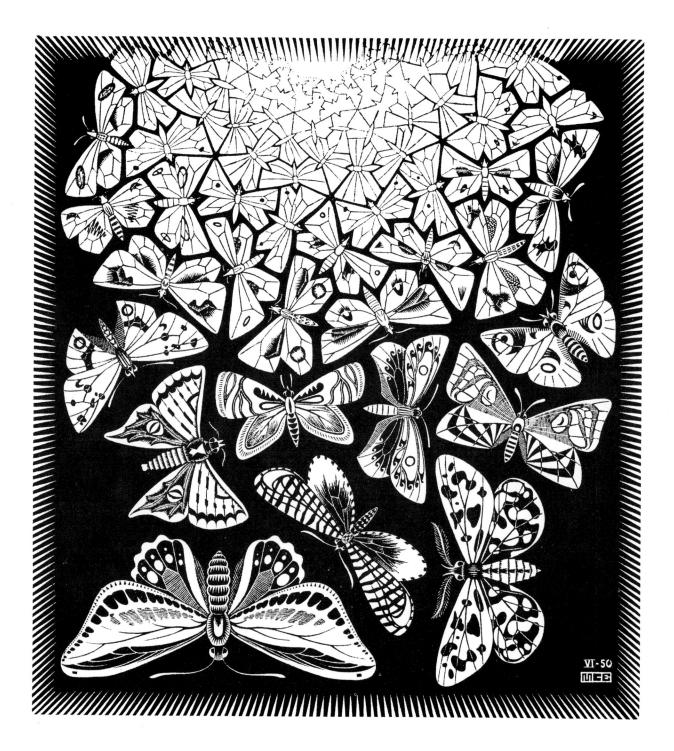

27. Vlinders - Butterflies - Schmetterlinge - Papillons

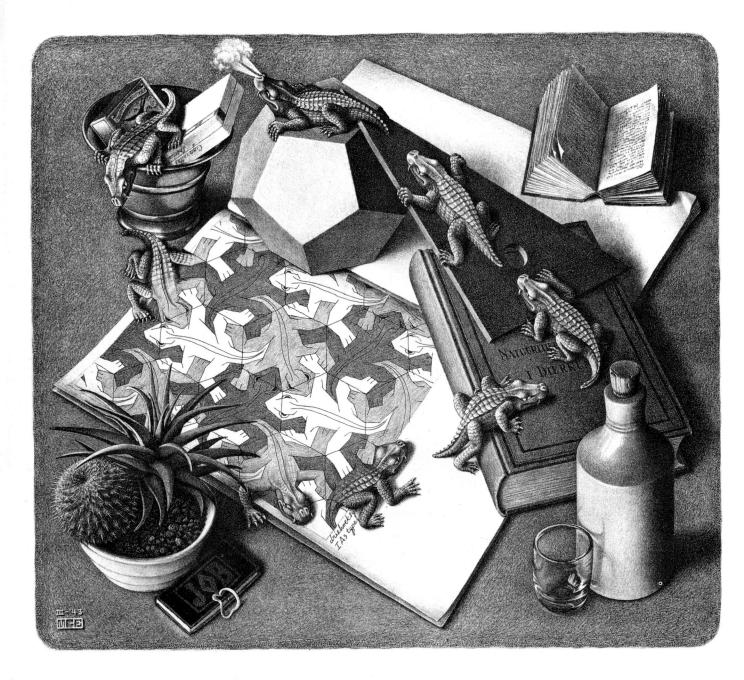

28. Reptielen - Reptiles - Reptilien - Reptiles

29. Kringloop - Cycle - Kreislauf - Cycle

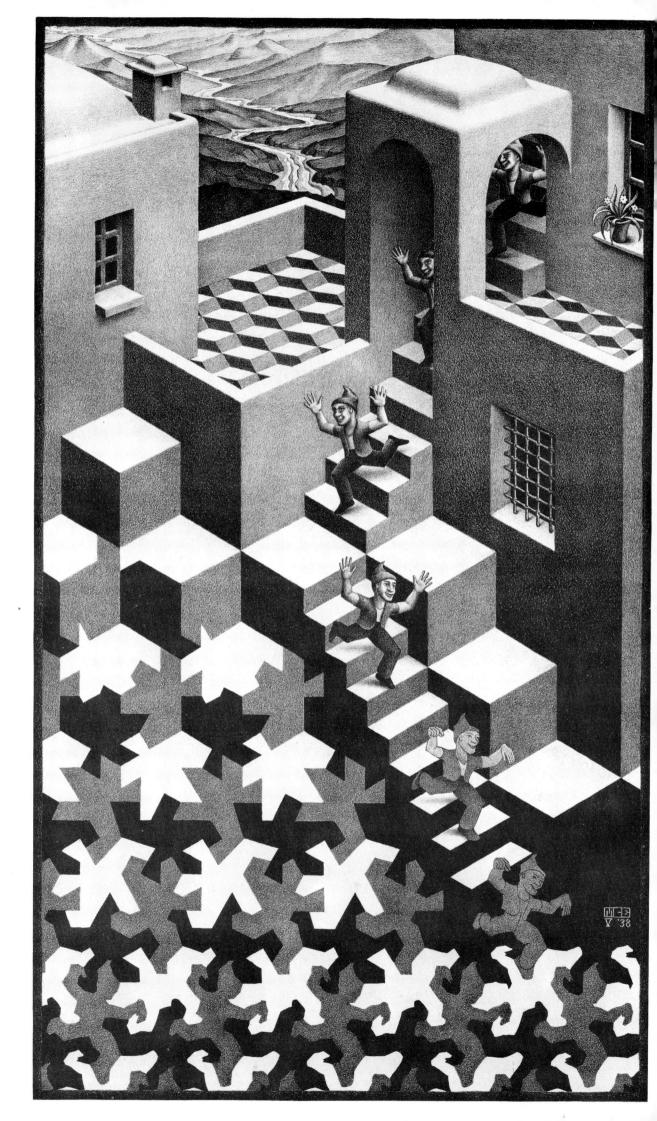

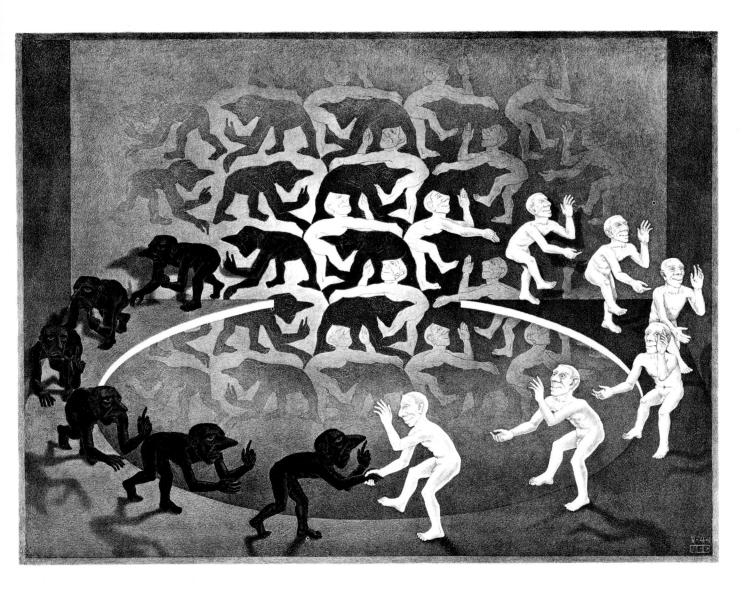

30. Ontmoeting - Encounter - Begegnung - Rencontre

31. Toverspiegel - Magic mirror - Zauberspiegel - Miroir magique

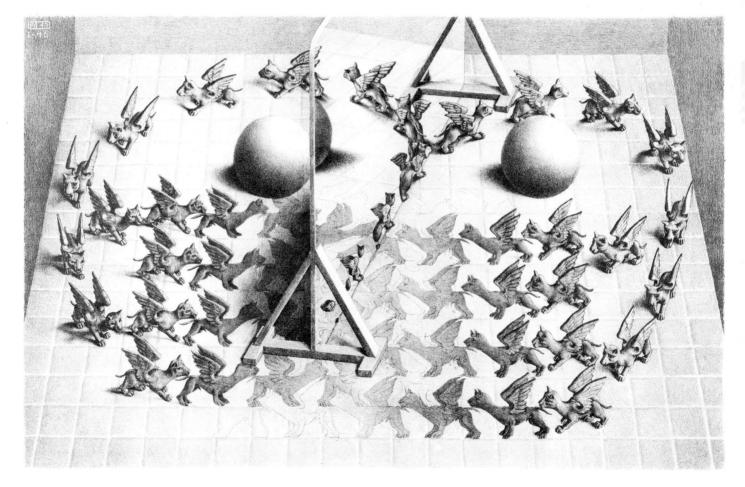

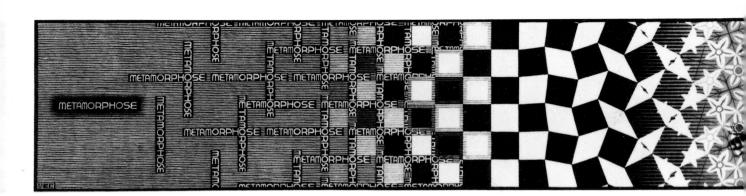

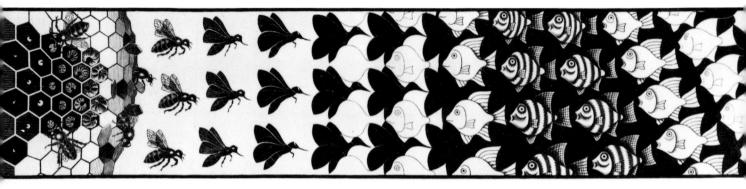

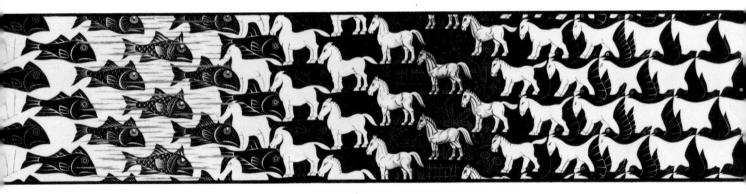

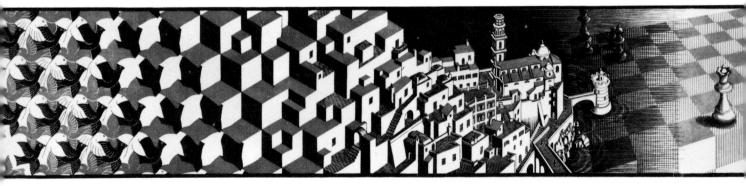

32. Metamorphose

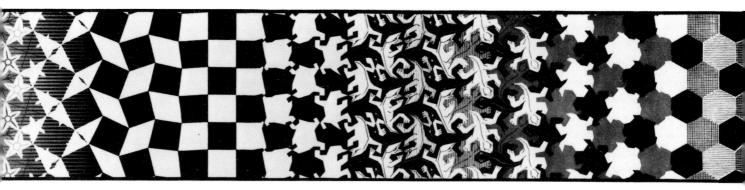

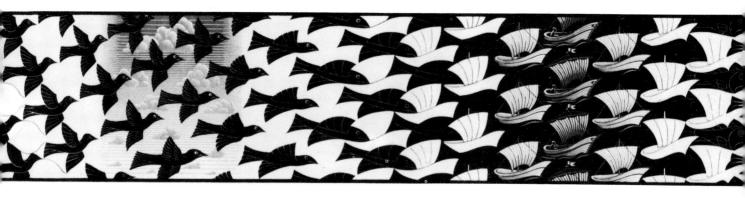

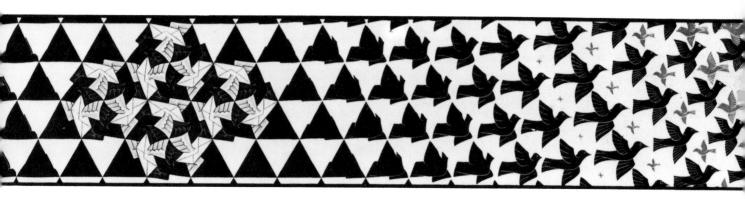

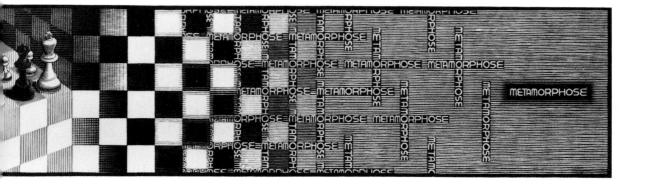

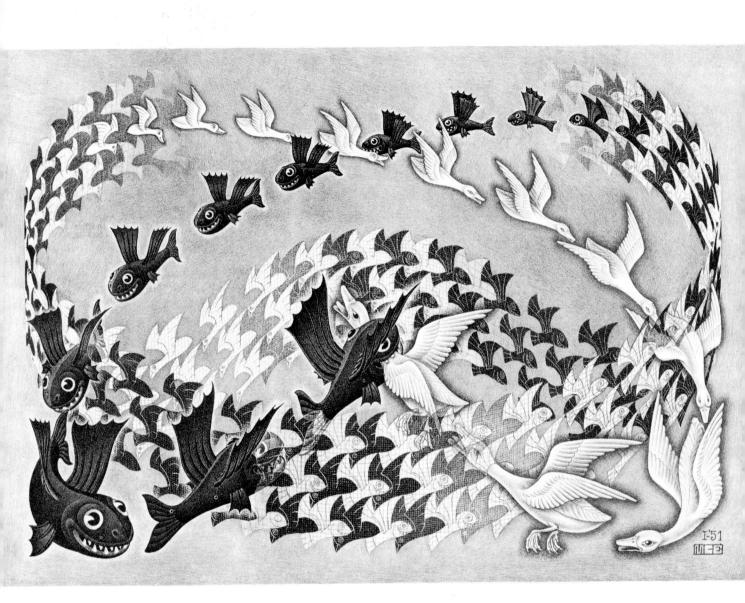

33. Predestinatie - Predestination - Prädestination - Prédestination

megseher Nº 48/50

eigendruke

34. Vlakvulling I - Mosaic I - Flächenfüllung I - Remplissage d'une surface I

35. Vlakvulling II - Mosaic II - Flächenfüllung II - Remplissage d'une surface II

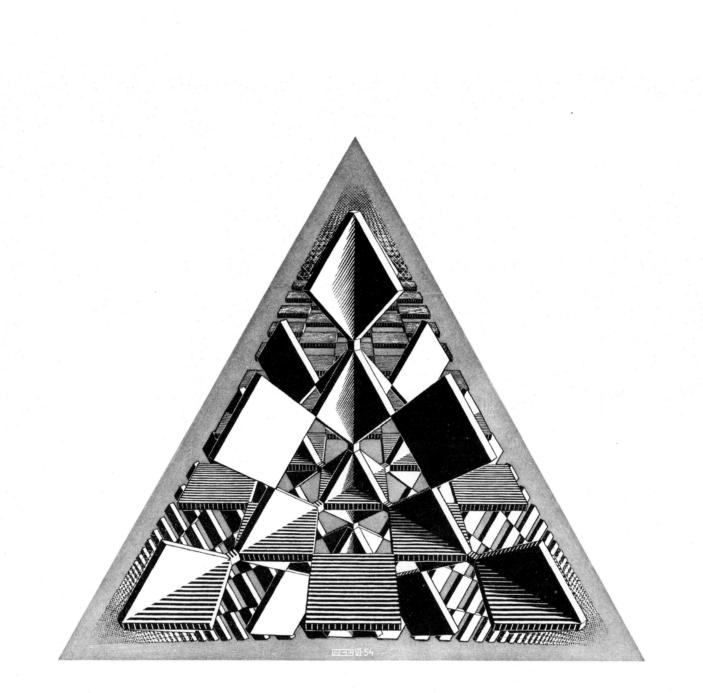

36. Drie snijdende vlakken - Three intersecting planes - Drei sich schneidende Flächen - Intersection de trois plans

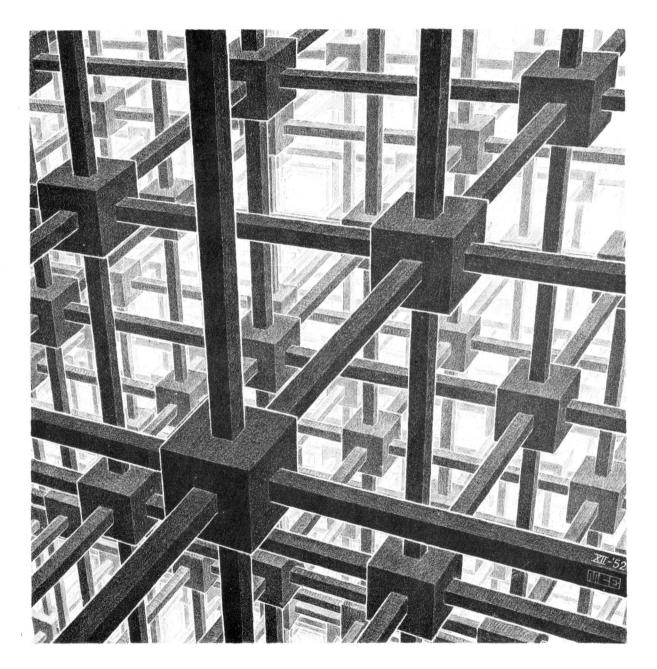

37. Kubische ruimteverdeling - Cubic space division - Kubische Raumaufteilung -Equipartition spatiale cubique

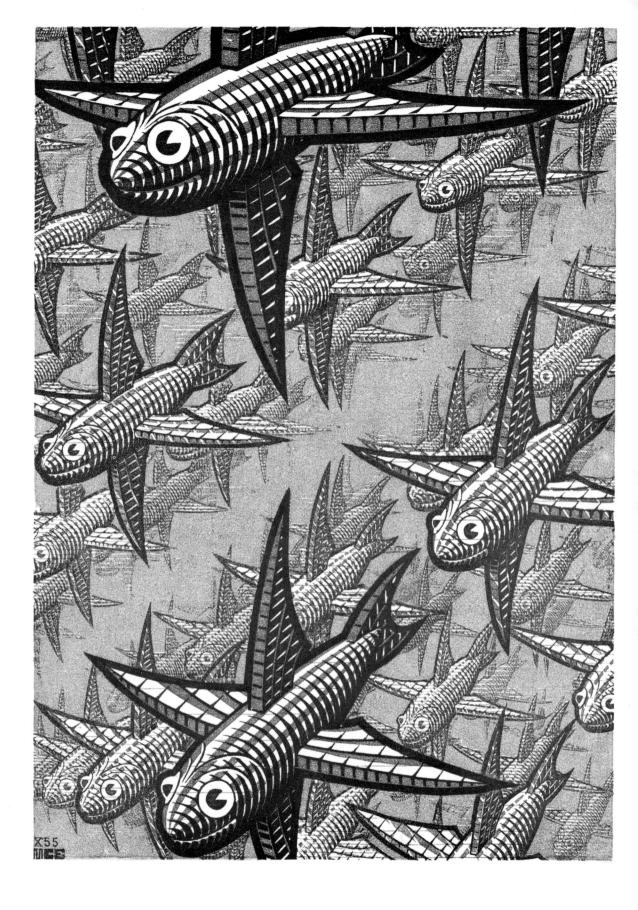

38. Diepte - Depth - Tiefe - Profondeur - Djup

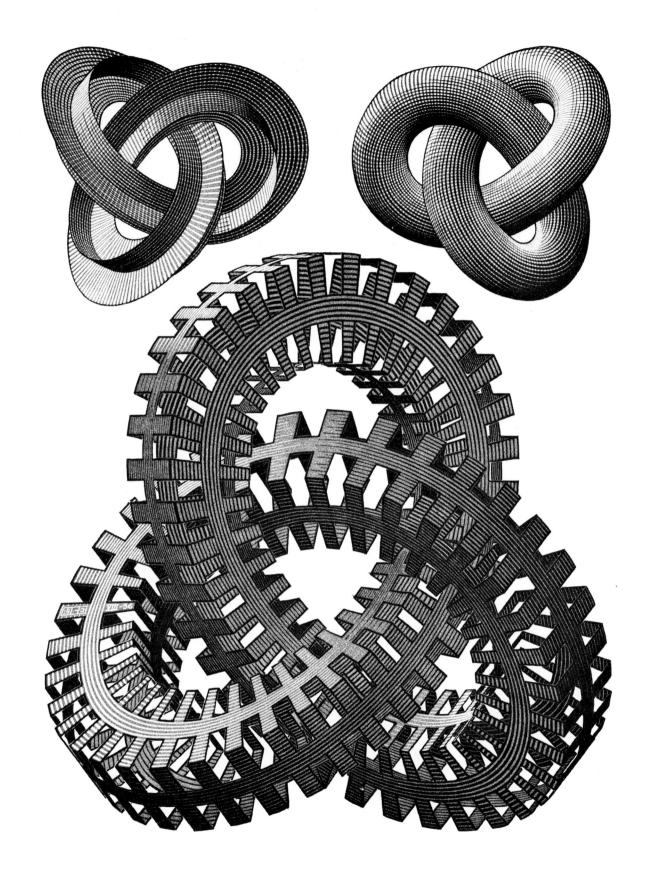

•

39. Knopen - Knots - Knoten - Noeuds

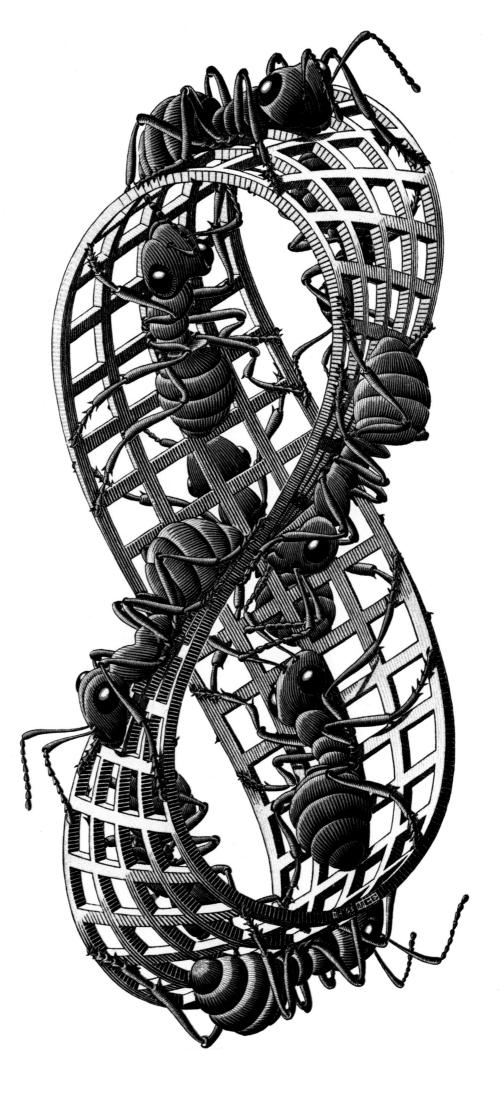

40. Band van Möbius II

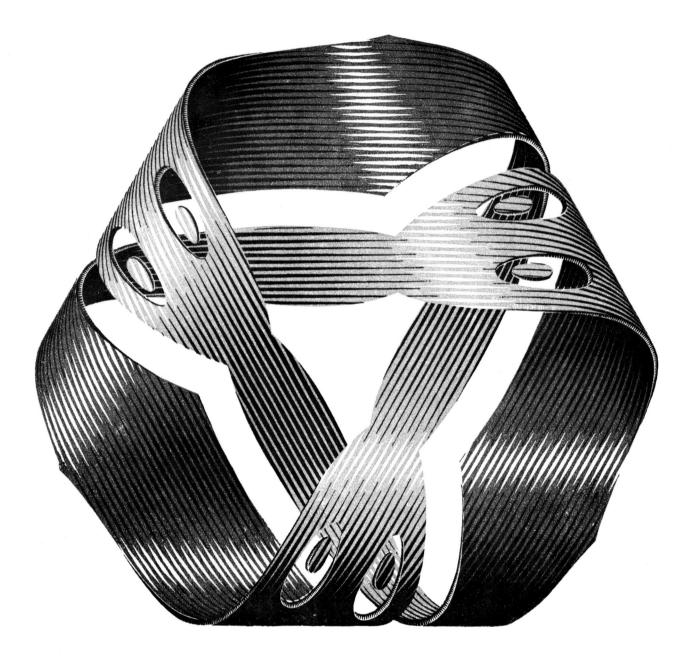

41. Band van Möbius I - Moebius strip I - Möbius-Streifen I - Ruban de Moebius I

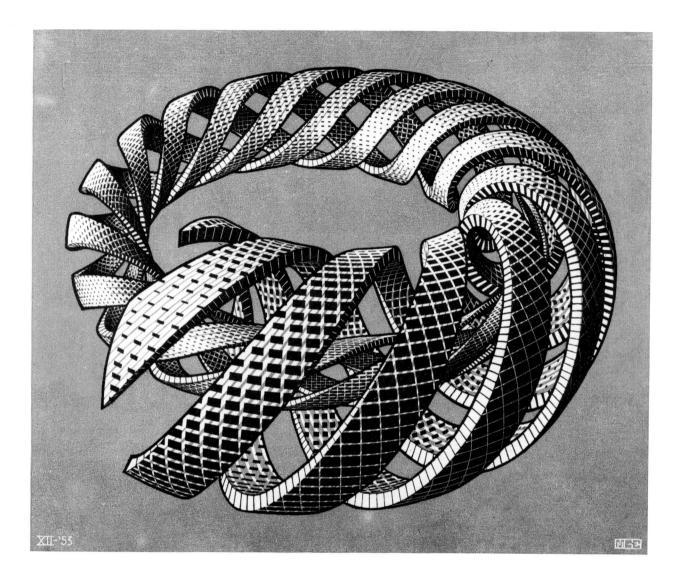

42. Spiralen - Spirals - Spiralen - Spirales

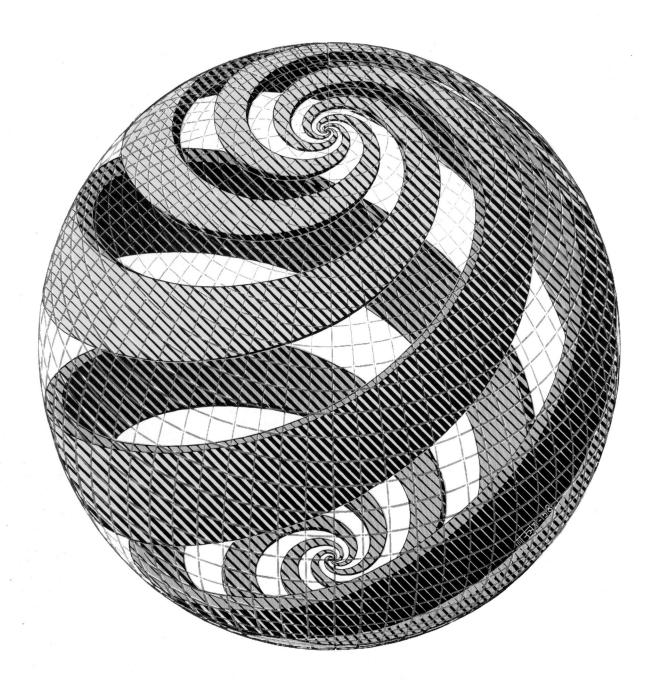

43. Bolspiralen - Sphere spirals - Kugelspiralen - Spirales sphériques

44. Concentrische schillen - Concentric rinds - Konzentrische Schalen - Remplissage concentrique de l'espace

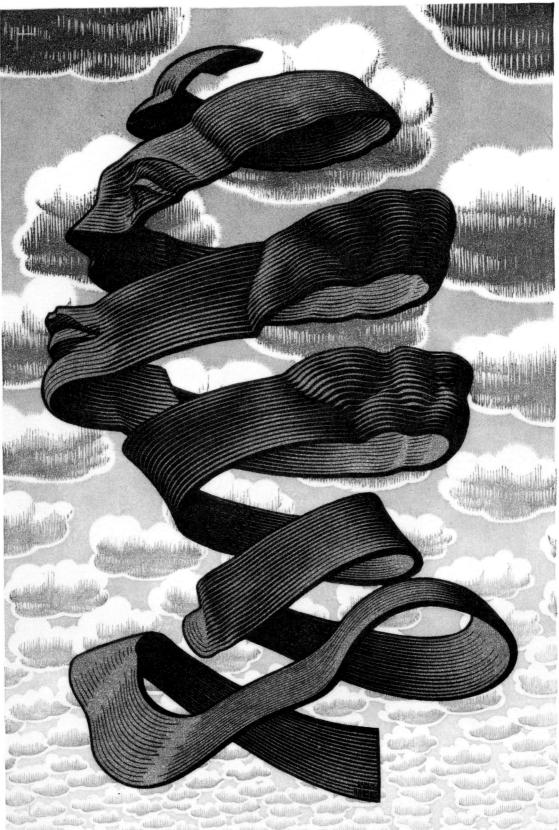

المعاللين الله . الأطالية عليها P AS WILLIAMS F. and have

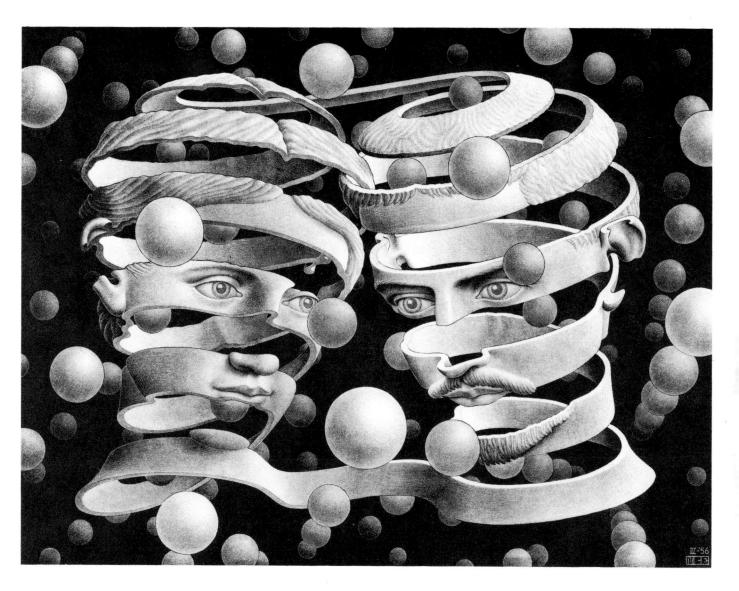

45. Omhulsel - Rind - Hülle - Enveloppe

46. Band - Bond of union - Band ohne Ende - Lien infini

47. Rimpeling - Rippled surface - Gekräuselte Wasserfläche - Cercles dans l'eau48. Drie werelden - Three worlds - Drei Welten - Trois mondes

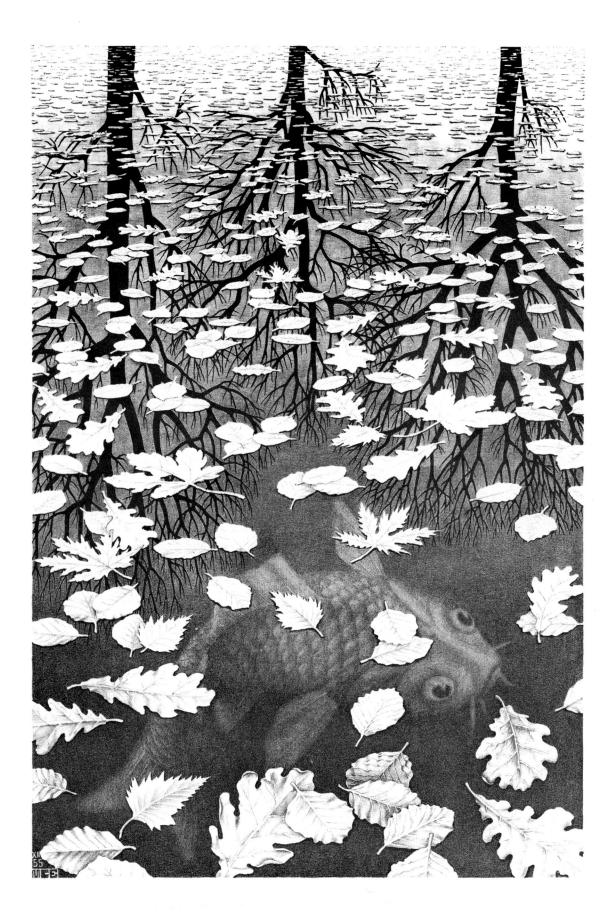

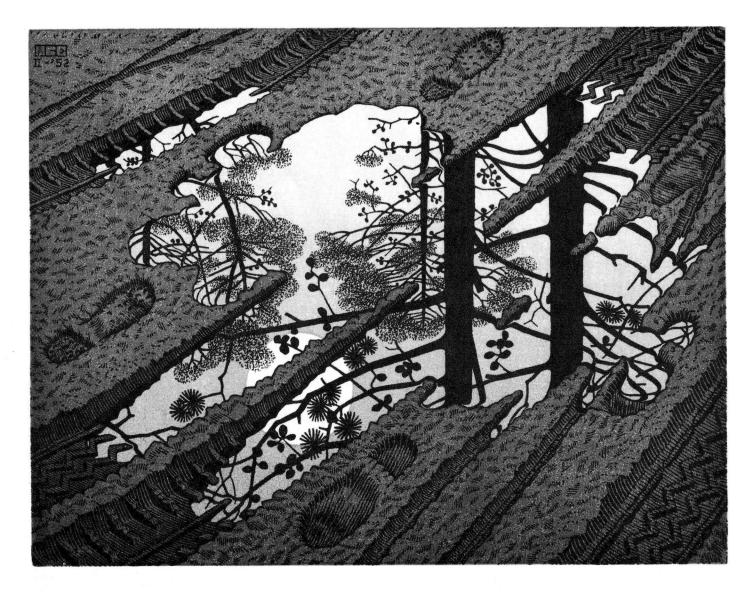

49. Modderplas - Puddle - Pfütze - Flaque d'eau

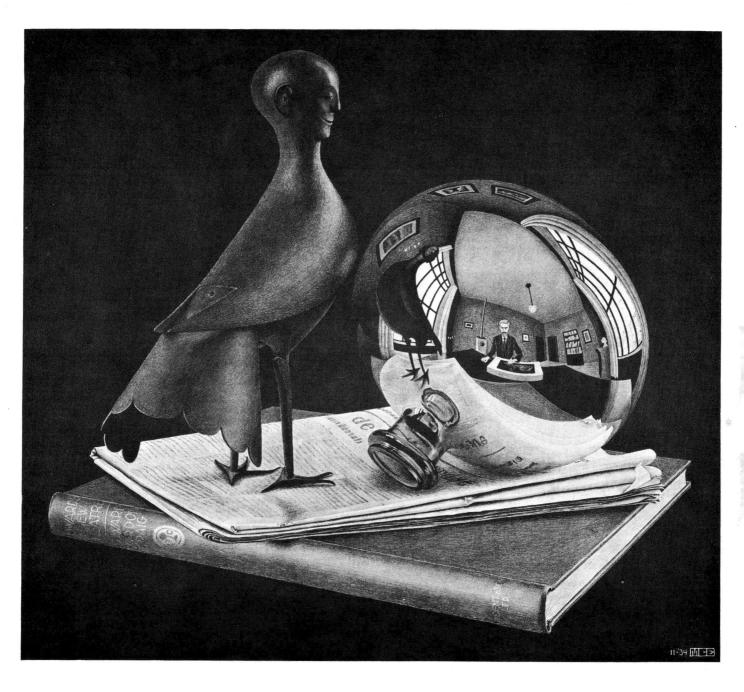

50. Stilleven met bolspiegel - Still life with reflecting globe - Stilleben mit spiegelnder Kugel -Nature morte avec sphère reflectante

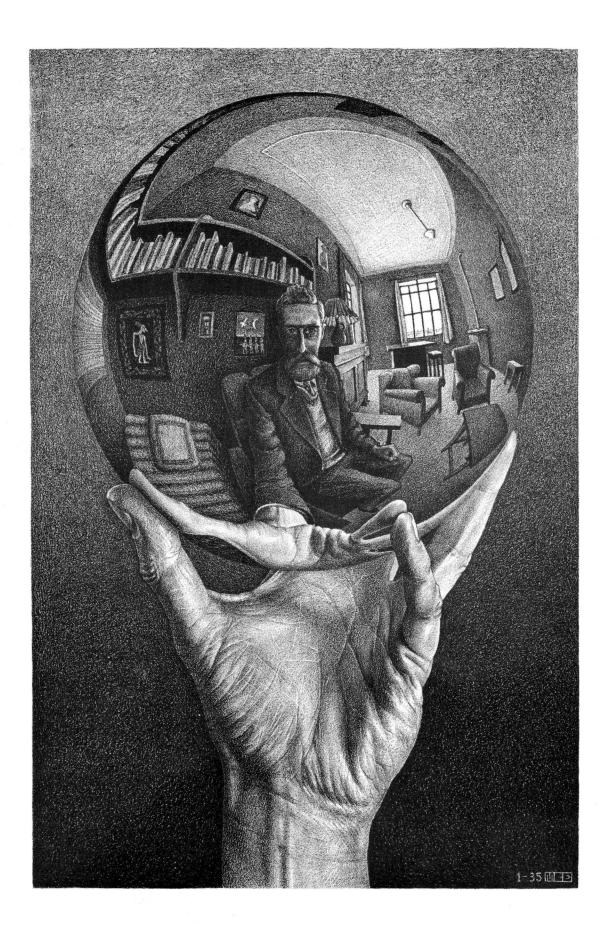

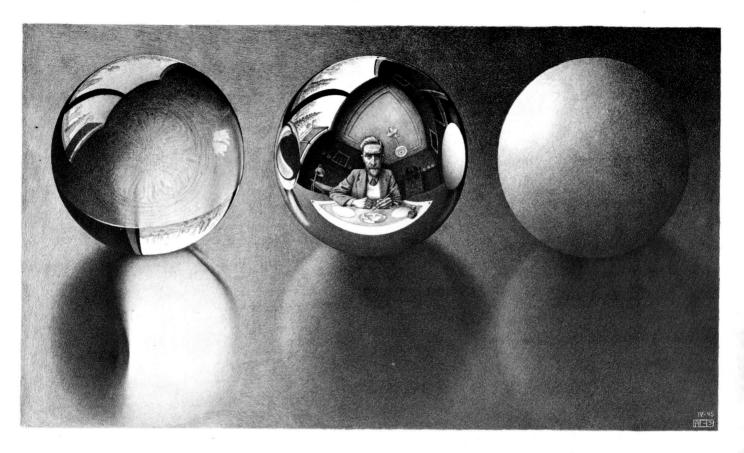

51. Hand met spiegelende bol - Hand with reflecting globe - Hand mit spiegelnder Kugel - Main avec sphère reflectante
52. Drie bollen II - Three spheres II - Drei Kugeln II - Trois sphères II

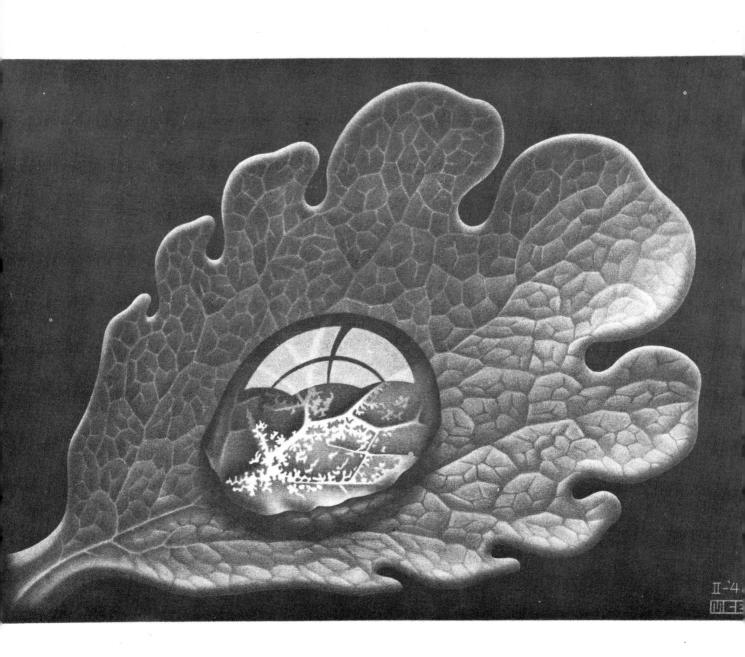

53. Dauwdruppel - Dew drop - Tautropfen - Goutte de rosée

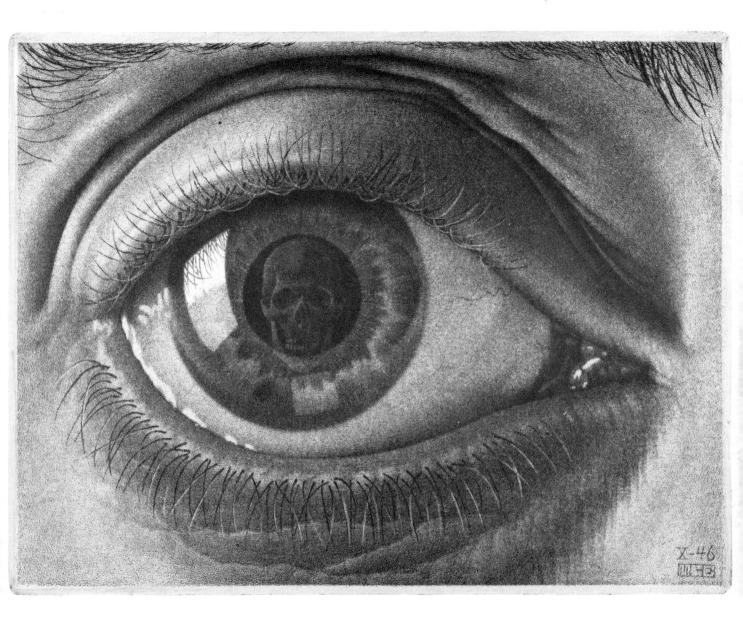

54. Oog - Eye - Auge - Oeil

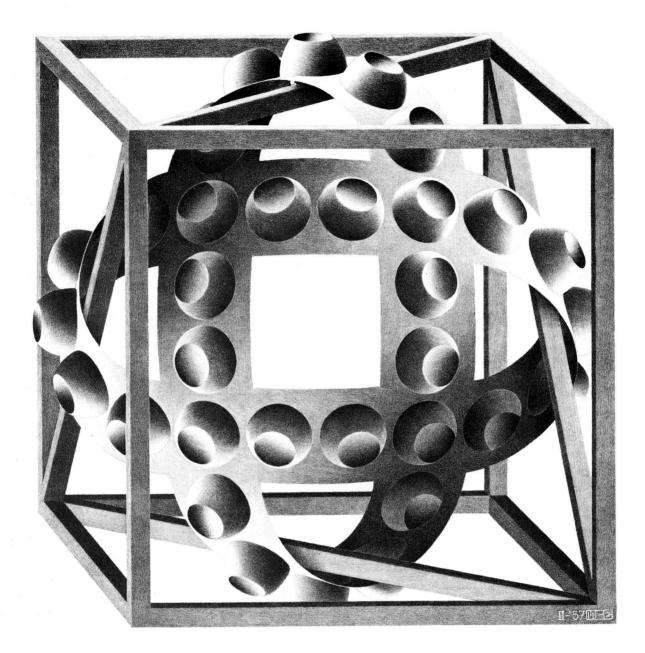

55. Kubus met banden - Cube with magic ribbons - Würfel mit magischen Bändern - Cube aux rubans magiques

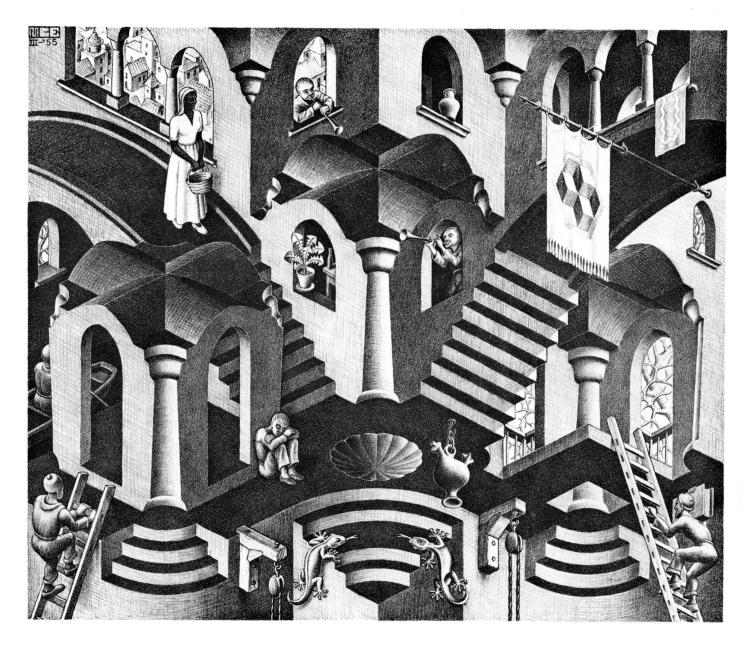

56. Hol en bol - Concave and convex - Konkav und Konvex - Concave et convexe

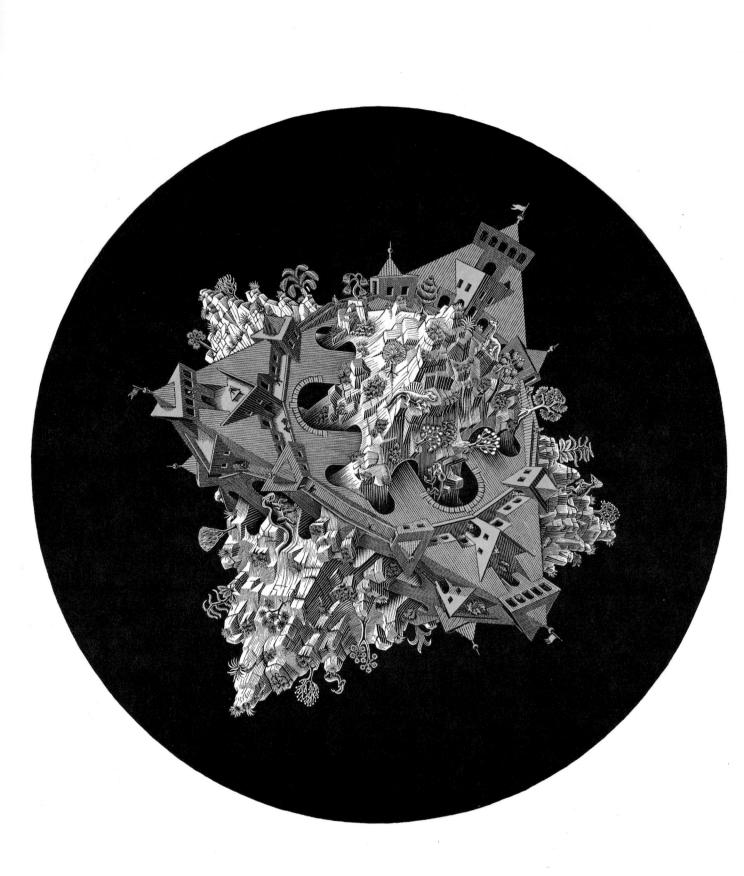

57. Dubbele planetoïde - Double planetoid - Doppelplanetoid - Planétoïde double

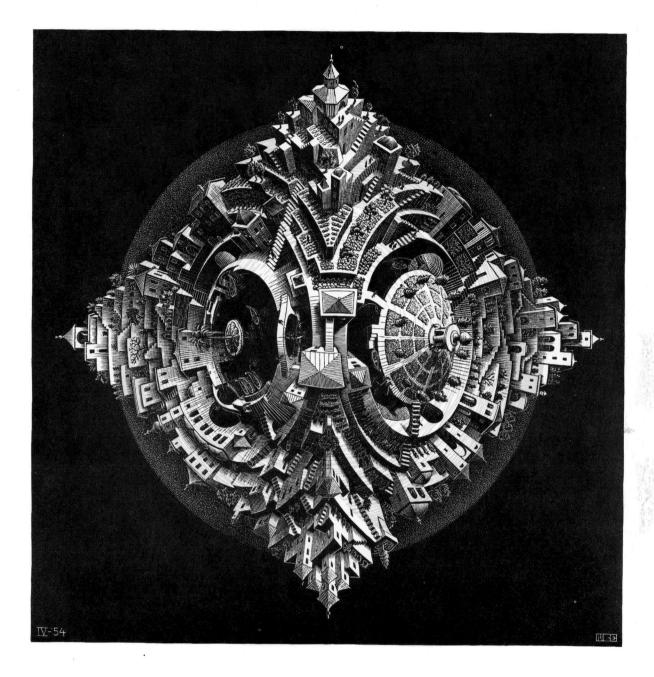

58. Viervlak-planetoïde - Tetrahedral planetoid - Vierflach-Planetoid - Planétoïde en tetraèdre

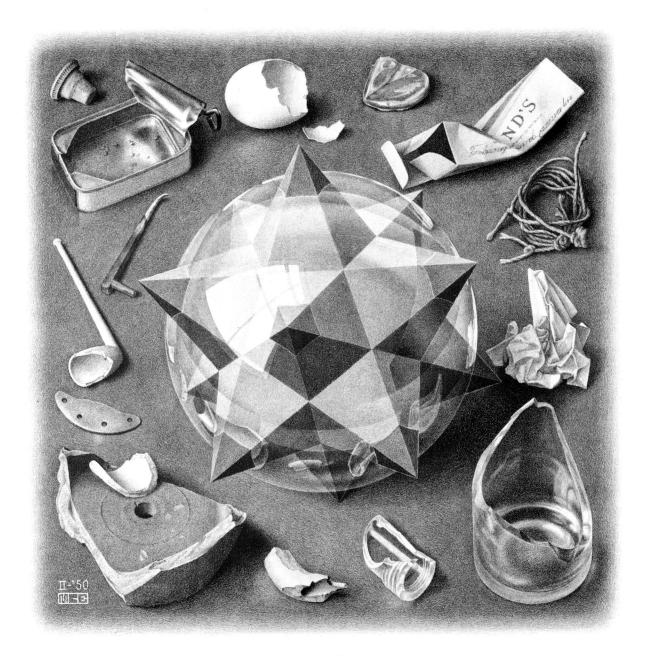

59. Tegenstelling - Order and chaos - Ordnung und Chaos - Contraste

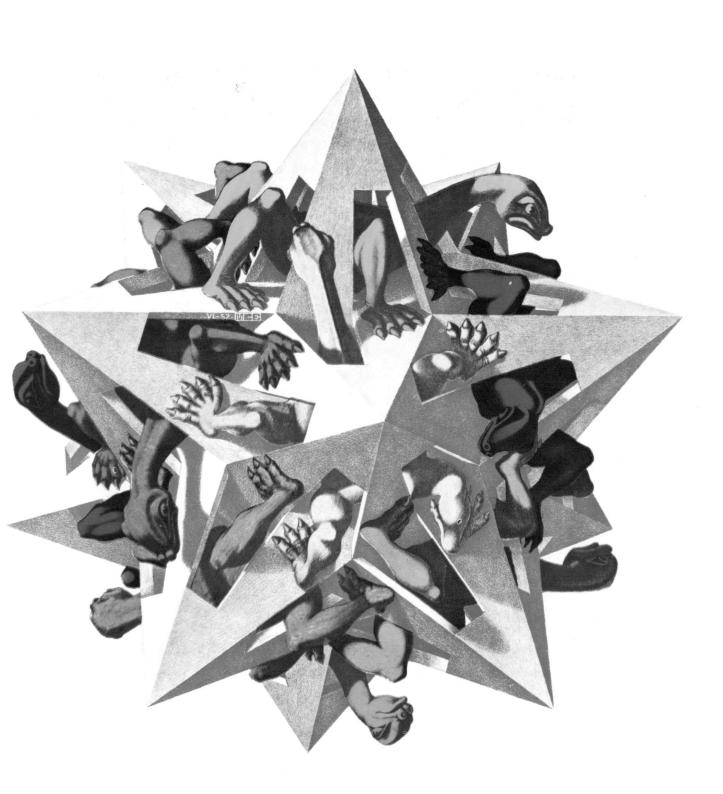

60. Zwaartekracht - Gravitation - Schwerkraft - Gravitation

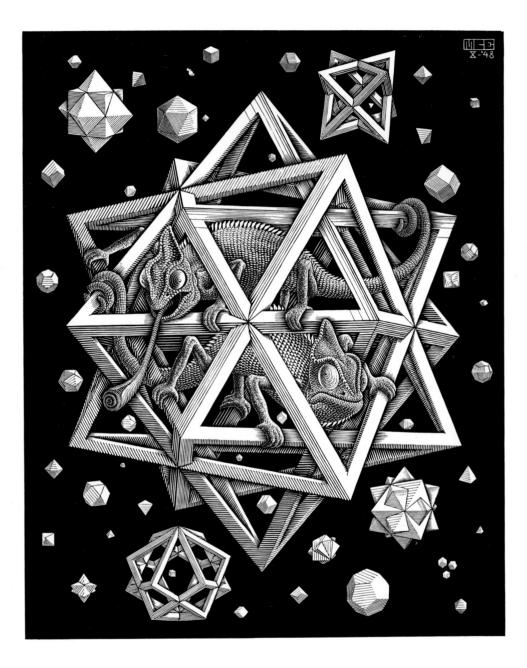

61. Sterren - Stars - Sterne - Etoiles

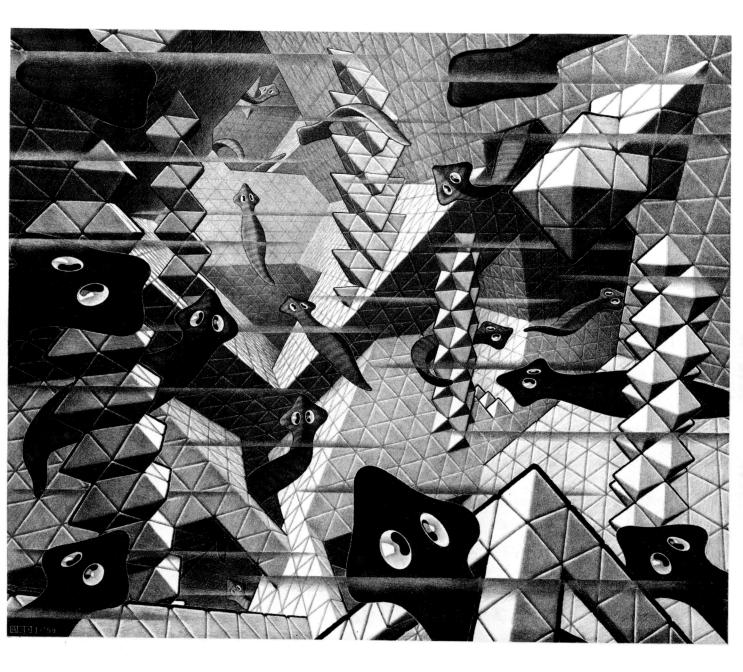

62. Platwormen - Flat worms - Plattwürmer - Planaires

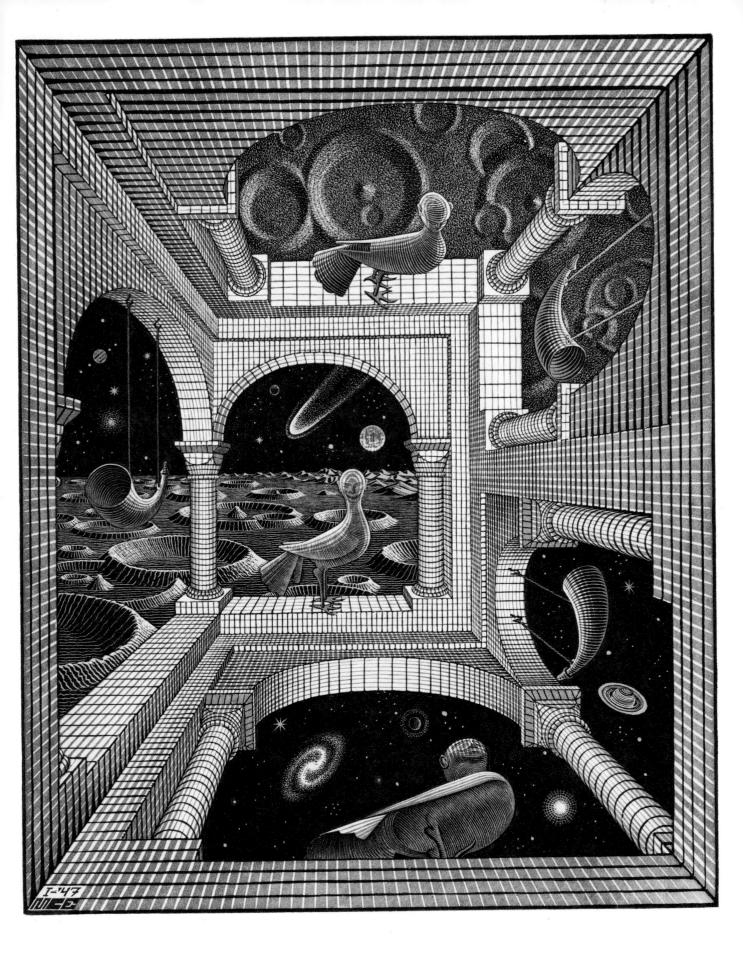

- 63. Andere wereld Another world Andere Welt Un autre monde
- 64. Boven en onder High and low Oben und unten Le haut et le bas

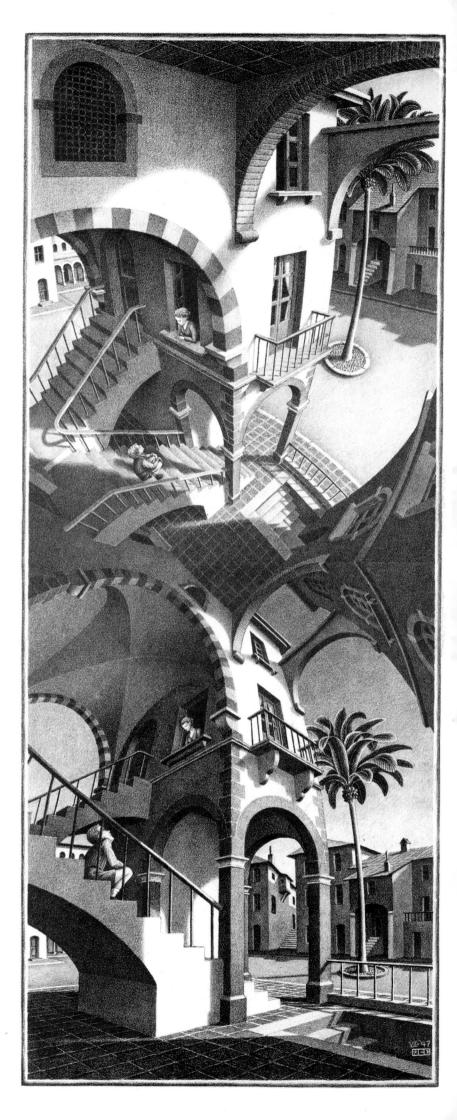

De Pedalternorotandomovens centroculatus articulosus ontstond, (generatio spontanea!) MI-H uit onbevredigdheid over het in de natuur ontbreken van wielvormige, levende schepse len met het vermosen zich rollend voort te bewegen. Het hierbij afgebeelde diertje, in de volksmond genaamd "wentelteefje" of "rolpens", tracht dus in een diepgevoelde be-hoefte te voorzien.Biologische bijzonderheden zijn nog schaars is het een zoogdier, een reptiel of een insekt? Het heeft een langgerekt, uit ver= hoornde geledingen gevormd lichaam en drie paren poten waarvan de uiteinden gelijkenis vertonen met de menselijke voet. In het midden van de dikke, ronde kop, die voorzien is van een sterk gebo gen papagaaiensnavel, bevinden zich de bolvormige en daar= ogen, die, op stelen geplaatst, ter weerszijden van toe een de kop ver uitsteken. In gestrekte positie kan betrekkelijk het dier zich, traag en bedachtzaam, door vlakke baan middel van zijn zes poten voort beweger over een willekeurig substraat tot zijn beschikking heeft drukt het (het kan eventueel steile trapper zijn kop op de grond en opklimmen of afdalen, door rolt zich bliksemsnel struikgewas heendringer op,waarbij het zich afduwt of over rots blokker met zijn poten voor zoveel deze dan nog de grond raken. In op= klauteren).Zo= dra het échter gerolde toestand vertoont het een lange de gedaante van een discus-schijf. weg moet waarvan decentrale as gevormd wordt door de ogen-op-stelen. Door zich beurteafleg ger lings af te zetten met een van zijn drie paren poten kan het een grote snelheid bereiken. Ook trekt het naar believen tijdens het rollen (by bij het afdalen van een helling, of om zijn vaart uit te lopen) de poten in en gaat "freewheelende"verder. Wanneer het er aanlei-ding toe heeft kan het op twee wijzen weer in wandel-positie oversaan: ten eerste abrupt, door zijn liehaam plotseling te strekken maar dan ligt het op zijn rug, met zijn poten in de lucht en ten tweede door geleidelijke snelheidsvermindering (remming met de XI-'51 poten) en langzame achterwaartse ontrolling in stilstaande toestand.

65. Wentelteefje - Curl-up - Krempeltierchen - Le roulenboule

66. Trappenhuis - House of stairs - Treppenhaus - Cage des escaliers

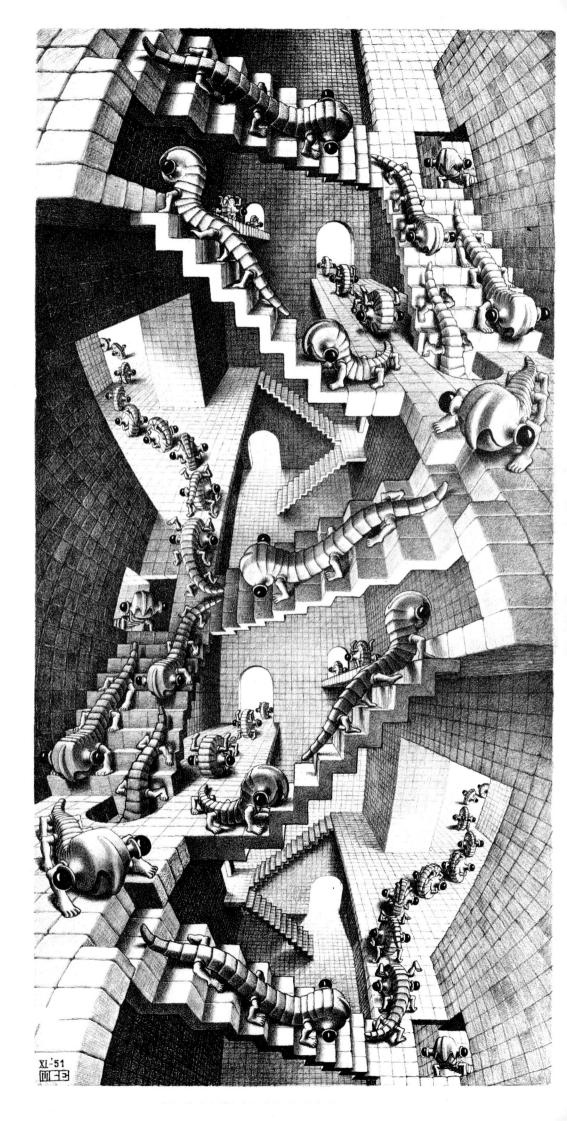

67. Relativiteit - Relativity - Relativität - Relativité

68. Drie bollen I - Three spheres I - Drei Kugeln I - Trois sphères I

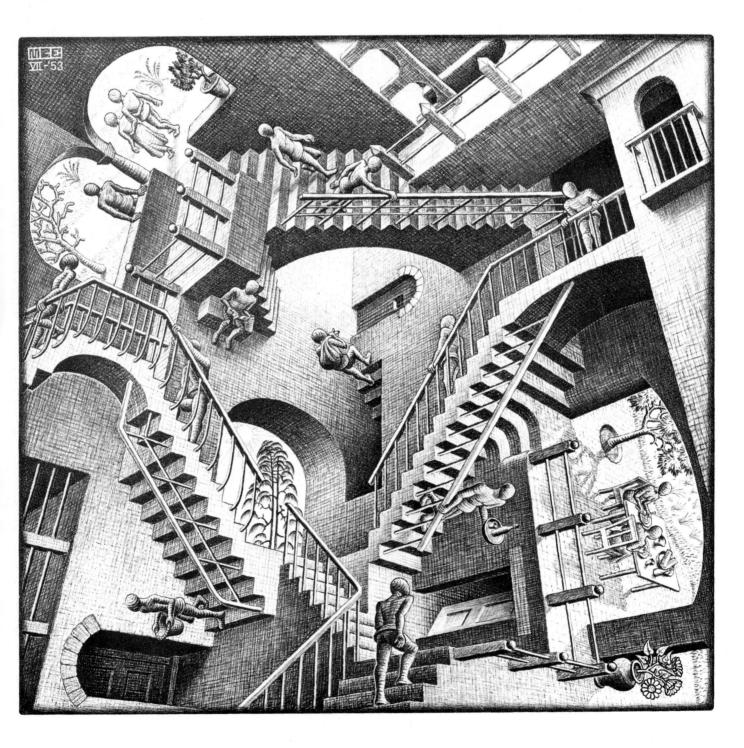

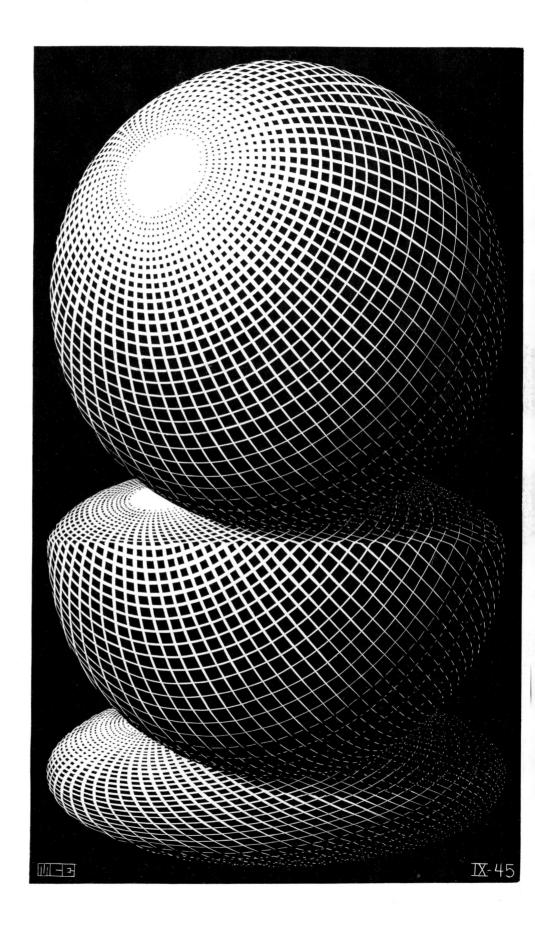

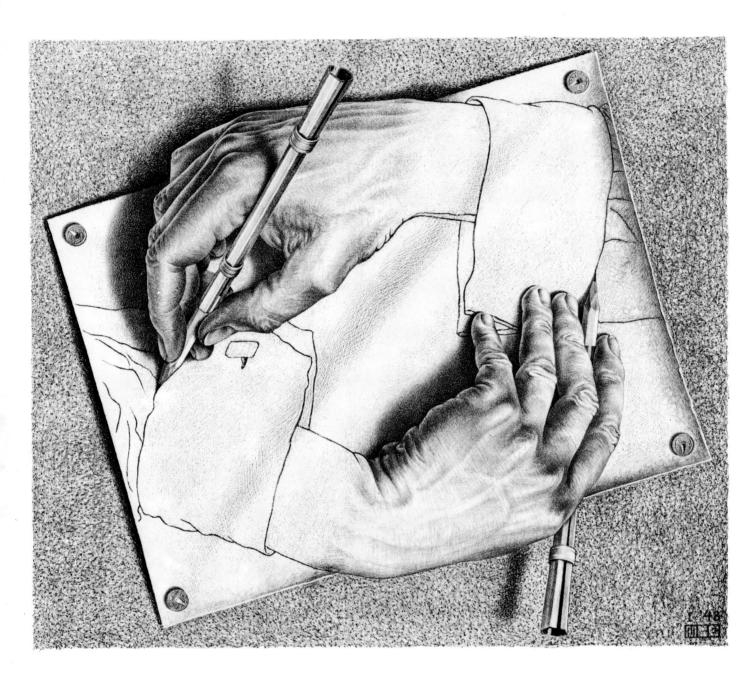

70. Balkon - Balcony - Balkon - Balcon

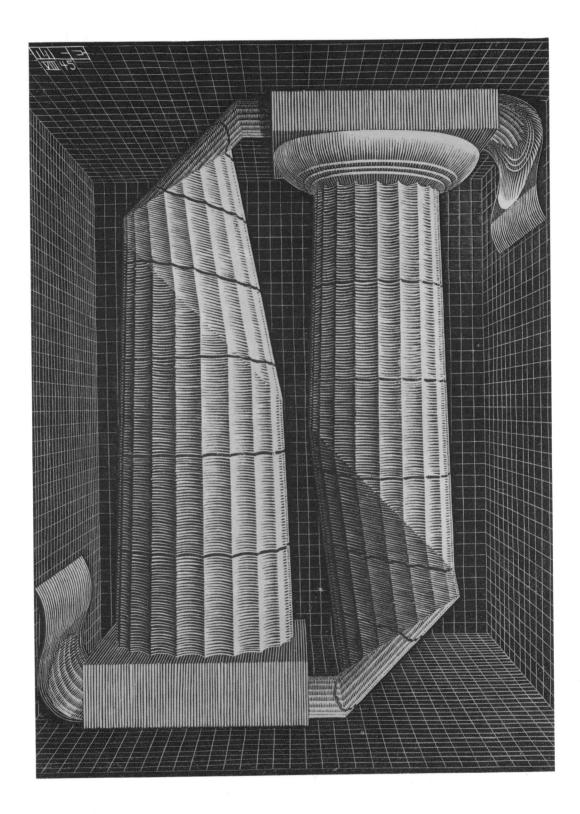

71. Dorische zuilen - Doric columns - Dorische Säule - Colonnes doriques

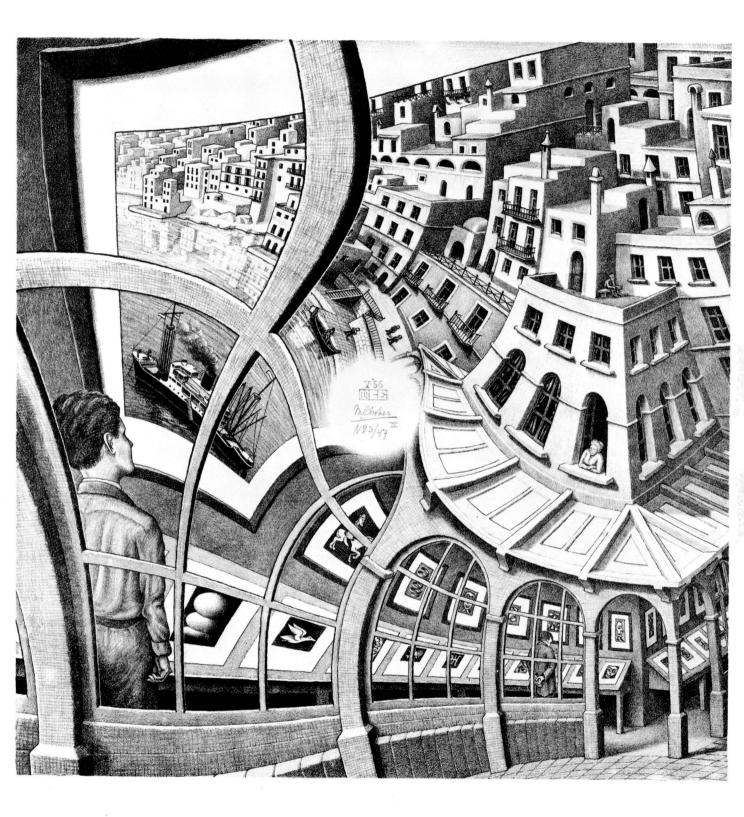

72. Prentententoonstelling - Print gallery - Bildergalerie - Exposition de gravures

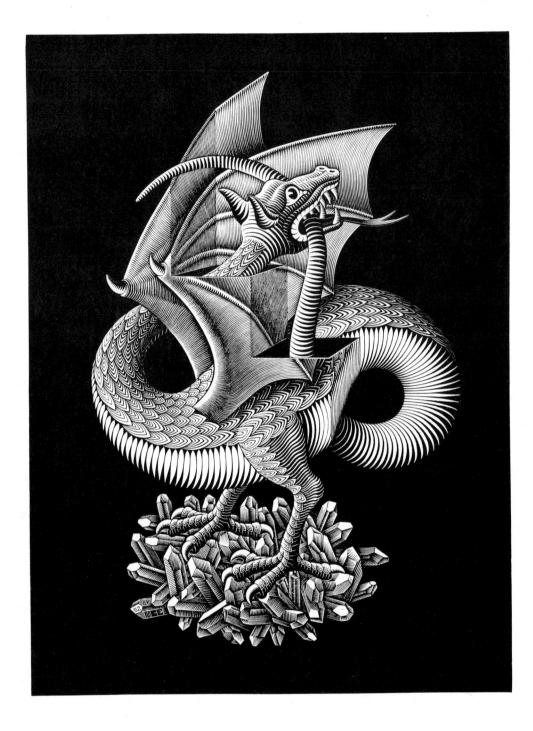

73. Draak - Dragon - Drache - Dragon

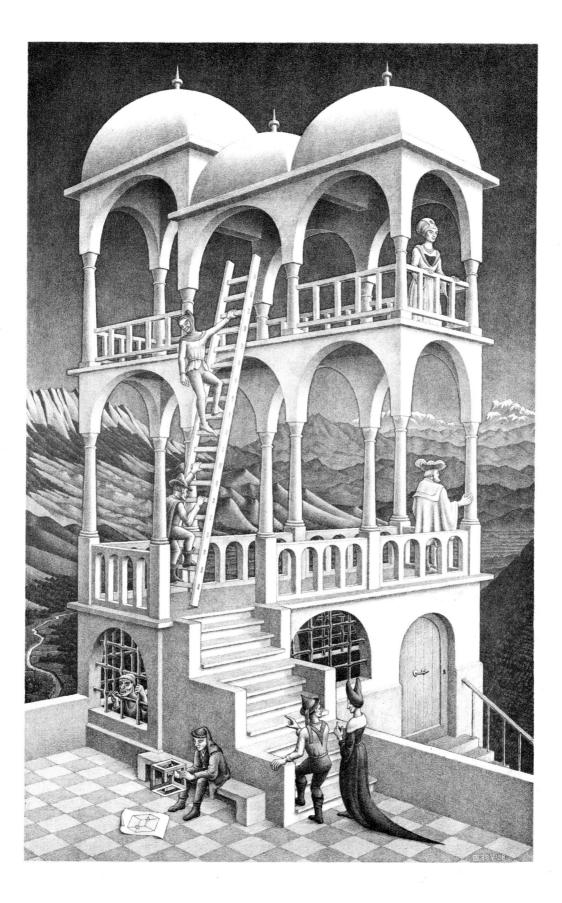

74. Belvedere

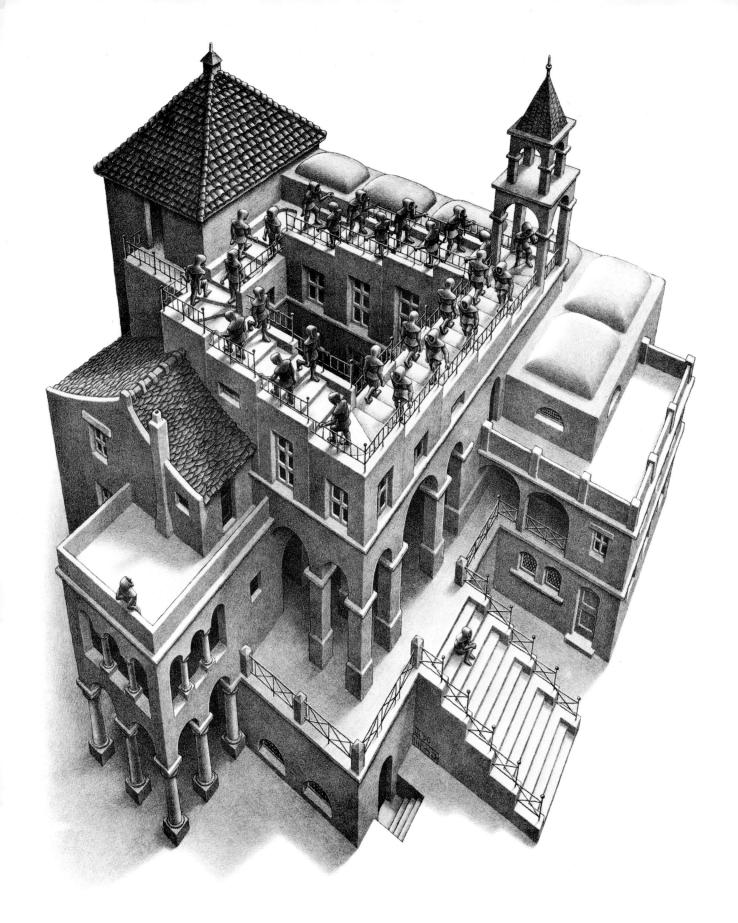

75. Klimmen en dalen - Ascending and descending - Treppauf und treppab - Montée et descente

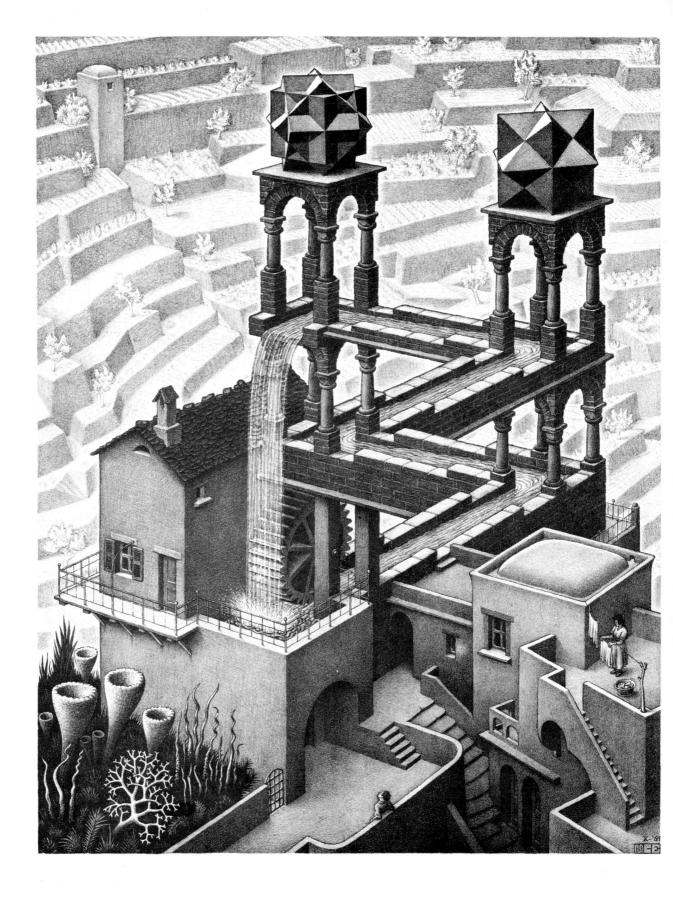

76. Waterval - Waterfall - Wasserfall - Cascade

Maurits Cornelis Escher, geboren 17 juni 1898 te Leeuwarden, ontving op de H.B.S. te Arnhem voortreffelijk tekenonderwijs van F. W. van der Haagen, die zijn grafische aanleg hielp ontwikkelen door hem het snijden in linoleum te leren.

Van 1919 tot 1922 bezocht hij de School voor Bouwkunde en Sierende Kunsten te Haarlem, waar hij onderricht ontving in de vrije grafische technieken van S. Jessurun de Mesquita, wiens sterke persoonlijkheid grote invloed heeft uitgeoefend op zijn verdere ontwikkeling als grafisch kunstenaar.

In 1922 vertrok hij naar Italië en vestigde zich in 1924 te Rome. Gedurende de tien jaren van zijn verblijf aldaar maakte hij vele studiereizen en bezocht o.a. de Abruzzen, de Amalfitaanse kust, Calabrië, Sicilië, Corsica en Spanie.

In 1934 verliet hij Italië, verbleef achtereenvolgens twee jaren in Zwitserland en vijf jaren in Brussel en woonde sinds 1941 in Baarn in Holland, waar hij op 27 maart 1972 op 73-jarige leeftijd overleed. Maurits Cornelis Escher, born in Leeuwarden, 17 June 1898, received his first instruction in drawing at the secondary school in Arnhem, by F. W. van der Haagen, who helped him to develop his graphic aptitude bij teaching him the technique of the linoleum cut.

From 1919 to 1922 he studied at the School of Architecture and Ornamental Design in Haarlem, where he was instructed in the graphic techniques by S. Jessurun de Mesquita, whose strong personality greatly influenced Escher's further development, as graphic artist. In 1922 he went to Italy and in 1924 settled in Rome. During his 10 year stay in Italy he made many study-tours, visiting Abruzzia, the Amalfi coast, Calabria, Sicily, Corsica and Spain.

In 1934 he left Italy, spent two years in Switzerland and five years in Brussels before settling in Baarn (Holland) in 1941, where he died on March 27, 1972, at the age of 73 years.

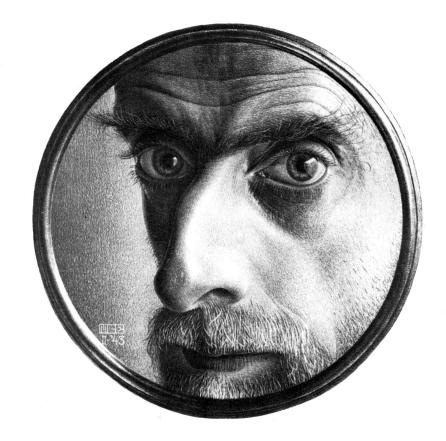

Maurits Cornelis Escher wurde am 17. Juni 1898 in Leeuwarden geboren. Er hatte auf der Oberschule in Arnheim einen ausgezeichneten Zeichenunterricht bei F. W. van der Haagen, der durch Unterweisen im Linolschnitt sehr zur Entwicklung von Eschers graphischer Veranlagung beitrug. Von 1919 bis 1922 besuchte er die Schule für Architektur und künstlerische Ornamentik in Haarlem, wo S. Jessurun de Mesquita in den freien graphischen Techniken sein Lehrer war. Mesquitas starke Persönlichkeit hat ebenfalls grossen Einfluss auf Eschers weitere Entwickling zum Graphiker ausgeübt. 1922 zog er nach Italien und liess sich 1924 in Rom nieder. Während der zehn Jahre seines dortigen Aufenthalts machte er viele Studienreisen, so besuchte er die Abruzzen, die Amalfi-Küste, Kalabrien, Sizilien, Korsika und Spanien. 1934 verliess er Italien, blieb nacheinander zwei Jahre in der Schweiz und fünf Jahre in Brüssel und wohnte seit 1941 in Baarn in Holland, wo er am 27 März 1972 im Alter von 73 Jahren verstarb.

Maurits Cornelis Escher, né le 17 juin 1898 à Leeuwarden, reçut au Lycée de Arnhem d'excellentes leçons de dessin de F. W. van der Haagen qui l'aida à développer ses dispositions pour l'art graphique en lui enseignant la gravure sur linoléum.

De 1919 à 1922 il fréquenta l'Ecole d'Architecture et des Arts Décoratifs de Haarlem, où il fut initié aux techniques graphiques libres par S. Jussurun Mesquita, dont la forte personnalité eut une influence puissante sur son développement ultérieur d'artiste graphique. En 1922 il partit pour l'Italie et s'établit en 1924 à Rome. Pendant ce séjour il fit de nombreux voyages d'études et visita notamment les Abruzzes, la côte d'Amalfi, la Calabre, La Sicile, la Corse et l'Espagne. En 1934 il quitta l'Italie puis passa successivement deux ans en Suisse et cinq à Bruxelles. Depuis 1941 il habitait à Baarn en Hollande où il mourut le 27 mars 1972, agé de 73 ans.